The Photography of
Alfred Stieglitz
Georgia O'Keeffe's Enduring Legacy

Edited by Therese Mulligan

Essays by Eugenia Parry, Laura Downey, and Therese Mulligan

GEORGE EASTMAN HOUSE
*International Museum of
Photography and Film*

George Eastman House

International Museum of Photography and Film

900 East Avenue

Rochester, NY 14607-2298

(716) 271-3361

www.eastman.org

Printed in the United States of America
ISBN (pbck): 0-935398-23-6

Library of Congress Cataloging-in-Publication Data

Stieglitz, Alfred, 1864–1946.

The photography of Alfred Stieglitz: Georgia O'Keeffe's enduring legacy/edited by

Therese Mulligan; essays by Eugenia Parry, Laura Downey, and Therese Mulligan.

p. cm.

ISBN 0-935398-23-6 (pbck)

1. Photography, Artistic—Catalogues. 2. Stieglitz, Alfred, 1864–1946—Catalogues. 3.

George Eastman House—Catalogues. 4. Photograph collections—New York—Rochester—

Catalogues. I. Mulligan, Therese. II. George Eastman House. III. Title.

TR653 .S784 2000

770.92—dc21

0-034745

Front-cover image: *Alfred Stieglitz (American, 1864–1946). GEORGIA O'KEEFFE, 1920. Gelatin silver print.*
Part purchase and part gift of An American Place, ex-collection Georgia O'Keeffe.

Back-cover image: *Robert W. Brown (American, active 1930s). ALFRED STIEGLITZ, 1939. Gelatin silver print.*
Gift of the photographer.

contents

From the beginning, a defining feature of George Eastman House has been the way in which its many collections often speak in one voice about a particular photographer, a historical moment, or culture at large. The earliest architects of the collections, especially Beaumont Newhall, the Museum's first curator and second director, understood the inherent interrelation of the Museum's collections. Together, these individuals forged photography's history, addressing both aesthetic and cultural issues. Personal papers. Journals. Cameras. Photographs. All these were considered intertwining parts that completed a whole picture and delivered a compelling story about the medium.

Items from the Alfred Stieglitz collection span four of the Museum's archival collections: photography, technology, library, and the newly established George Eastman Archive. Working with the photographer's executrix, the great American painter Georgia O'Keeffe, and her colleague Doris Bry, Beaumont Newhall acquired through gift and purchase objects and print material pertaining to Stieglitz over the course of two decades, beginning in 1951. At the same time, he augmented the Stieglitz collection through other sources, including Dorothy Norman.

This publication and its accompanying traveling exhibition exemplify Newhall's and O'Keeffe's desire to present a collective picture of Stieglitz in which his contributions to photographic history are portrayed in both word and image. Similar to the guide to the Museum's photography collection, *Photography from 1839 to Today* (1999), this book furthers the Museum's mission to provide greater public and scholarly access to the collections while illuminating the aesthetic and cultural ties that bind them.

On behalf of the Board of Trustees, I wish to acknowledge the entire staff of George Eastman House, in particular Therese Mulligan, curator of photography, who led a collaborative team of dedicated museum professionals in the creation of this publication and exhibition. I also wish to thank The Publishing Trust of George Eastman House for its generous support of publishing projects, such as this, which address the breadth and depth of the Museum's collections, and the Eastman Kodak Company, particularly Essie Calhoun, for sponsoring the accompanying traveling exhibition.

Anthony Bannon,
Director, George Eastman House

essays

Georgia O'Keeffe's Enduring Legacy: The Stieglitz Collection

Therese Mulligan

The 1951 acquisition of work by the esteemed photographer Alfred Stieglitz from his widow Georgia O'Keeffe, the executrix of the photographer's estate, proved integral to the formation of George Eastman House's collections and its mission. Opened in 1949 in the home of George Eastman, founder of Eastman Kodak Company, the Museum was the first American institution whose specific objectives were to preserve, interpret, and exhibit photography and motion pictures. Under the twenty-year leadership of the eminent photography historian Beaumont Newhall, the Museum's first curator and second director, the collections assumed much of the influential character and distinction that continues to define them today.

Newhall's approach to building the Museum's unique collections at a time when very few art or cultural institutions attempted to do so was broad and in depth. He was assisted in his work by Eastman Kodak Company, whose Historical Photographic Collection, which included photographic and photomechanical material as well as its accompanying technology, was transferred to the Museum in 1948, the year after its founding. This collection was the cornerstone to the collection's foundation, with its vast nineteenth-century French and British holdings. Subsequent acquisitions of the Alden Scott Boyer collection of British photography, technology, and print ephemera, and the Louis Walton Sipley/3M collection, with its particular American emphasis, helped realize Newhall's drive to shape collections that were representative of the totality of photography, its practice, and thought.[1] This approach held true in Newhall's involvement with the Stieglitz estate, for over the course of his tenure at Eastman House, he, in partnership with O'Keeffe, garnered significant acquisitions for the Museum's collections of photography, technology, and the library.

A cache of correspondence held by the Museum provides fresh insight into the development of its Stieglitz collection. Letters between Newhall, O'Keeffe, and her assistant Doris Bry span the years 1948 to 1965, and the material ends in 1972 with letters from the Museum's third director, Van Deren Coke, to O'Keeffe. While the letters often address issues pertaining to the care and use of the collection, a perennial concern, they also, in later years, evidence O'Keeffe's ambivalence as to what to do with estate material that remained after she had made initial contributions to collecting institutions.

Commencing with the photographer's death in 1946, O'Keeffe, working with Bry, had assembled the estate photographs into representative sets encompassing the range of Stieglitz's career. She then presented these sets as gifts to several notable American art museums, seeking to preserve Stieglitz's work and his inestimable legacy as a defining figure in American art and photography (see subsequent essay). As it was not yet established at the time O'Keeffe made her first distributions, the Eastman House received its estate set later than other museums.

In addition, the process to secure the acquisition took more than a year, beginning in June 1950 and concluding in September 1951. During this time, Newhall was immersed in organizing, cataloguing, and housing the recent acquisition of the Boyer collection, which numbered more than 13,000 objects, and overseeing the construction of the 500-seat Dryden Theatre. He found few moments away from the pressing work at hand and did not travel to view the Stieglitz work put aside for the Museum until January 1951. He concurrently sought to receive the estate set as a gift, looking to extend O'Keeffe's earlier practice of donating to other museums.

In the few letters illuminating deliberations with O'Keeffe, and likewise with Bry, Newhall's attempts at persuasion ultimately met in a compromise, offered by O'Keeffe through Bry, to acquire the set as part gift and part purchase. As if to assure Newhall as to the uniqueness of the work and thus the appropriateness of the acquisition terms, Bry wrote in a letter of December 4, 1950:

> I would like to emphasize to you what I think I have said before, that I hope you realize that the group
> of prints set aside for George Eastman House is one of the finest Stieglitz print groups in the country.
> This seemed to us the sort of group you should have. In forming the group, we also made an effort
> to include one or two rare prints of historical interest which seemed particularly appropriate placed
> at Eastman House, and which are not duplicated in any other Museum group in the country (early carbon
> enlargements). You can never find as important a group of Stieglitz prints available for purchase or gift
> from any individual in the world—they do not exist—and you should have only the best!

On September 7, 1951, the Stieglitz collection at Eastman House was finally secured, with a set of eighty-seven objects, consisting of eighty-two photographs and five autochromes. (For the totality of works not defined as gifts, the acquisition purchase price was $4,000.) Yet the collection did not remain fixed in number for long. By the end of 1952, O'Keeffe contacted Newhall again to offer the Museum additional work—this time as a gift. This subsequent donation included photogravures by Stieglitz, as well as his contemporaries Frank Eugene and Alvin Langdon Coburn, images produced for Stieglitz's publication *Picturesque Bits of New York and Other Studies* (cat. 60, 61), and issues of *Camera Work* that would complete the library's two sets. In addition, she donated thirty-two lantern slides by the photographer and two paper negatives by the British team Hill and Adamson. But amid the correspondence of this period that discussed additional acquisitions are letters of extraordinary import in which O'Keeffe agonizes over the future of a group of items still left in the estate—Stieglitz's negatives.

In a letter dated November 12, 1952, O'Keeffe wrote to Newhall seeking advice, "I still have a few things to settle with the Stieglitz affairs and I would like to ask you a couple of questions." She continued:

> I have decided to destroy the negatives but I thought I would ask you if there be any reason that you might
> wish to have any for technical or historical interest of any kind…. He [Stieglitz] always spoke
> of not wanting any one [*sic*] to print his negatives. He didn't destroy them himself so I have hesitated.
>
> May I hear from you soon about this as I intend to destroy them soon.

Drawing upon his personal remembrances of Stieglitz, Newhall's response of November 21 was both emotionally and curatorially informed:

> I shudder at the thought of destroying, or even canceling, the Stieglitz negatives. I know how often Stieglitz spoke of destroying them—yet he never did. I can agree certainly that no one else can ever print them—but I wish that some less radical method of preventing their use might be found. We would be glad to store them here at Eastman House.... In the years to come, as study and appreciation of the medium of photography comes to be known, there will be work done by students comparable to what is now being done in the fields of the other arts. The negatives, to the trained observer, teach much, and I believe they should be preserved. It is for this purpose the George Eastman House exists.... I urge you, therefore, to turn the negatives over to us....

Swayed by his argument, O'Keeffe wrote to Newhall three days later that she accepted his proposal, but added that on that day she was destroying negatives too deteriorated to be preserved and canceling with a mark across their surfaces all remaining negatives so they could not be printed. In the same letter, she described more donations of Stieglitz photographs to the Museum, remarking:

> ...would you wish to have a print of everything I still have. I must not keep them. Life is too uncertain and it is something I should do myself. One way or another I should be finished with all these things.

The Stieglitz negatives arrived at Eastman House on February 16, 1953, with the condition that they would become the property of the Museum unless withdrawn by O'Keeffe prior to January 1, 1958, or in the event of her death. For the next five years, the negatives were preserved and studied by staff and researchers at the Museum, until December 30, 1958, when O'Keeffe, thinking better of her decision and acting on what she believed would be Stieglitz's true wishes, wrote to Newhall asking for their return. After many years of stops and starts, Newhall restored the negatives to O'Keeffe, via Bry, in 1965.[2]

The short-term inclusion of the negatives in the Stieglitz collection and Newhall's pursuit to acquire and keep them is a dramatic reminder of how he envisioned the Museum's collections to be mutual whole, rather than disparate parts. First and foremost was his view that the collections spoke in unison, and that understanding did not reside in acknowledgement of the photographic print alone, but in objects little appreciated at the time, including lantern slides and autochromes, as well as related materials of books, periodicals, correspondence, and technology. It is a practice often unrecognized by historians and critics today, that in contrast to the teleological history of photography that comprised Newhall's publication *History of Photography*, in other writings and curatorial activities he undertook an expansive and comprehensive approach to acquisition and exhibition. This was certainly the case when Newhall acquired Stieglitz's cameras from O'Keeffe.

Upon receipt of the cameras (see cat. entries 193–196) and accompanying apparatus,[3] Newhall placed them on display. For him, these objects were vital components to understanding Stieglitz's working habits and the types of subjects he sought to portray. For example, the Graflex camera (pl. 40, cat. 195), figured greatly in the creation of imagery made at the photographer's home at Lake George. Hand-held and relatively lightweight for the time, this

camera supported pictorial approaches that prized the immediacy of the present moment. It was integral to the success of his extended series *Equivalents*. Of work received from O'Keeffe, it is photographs from the *Equivalents* series that constitute a large portion of her contribution to the Eastman House.

Little studied today, lantern slides and autochromes were important vehicles of photographic expression at the turn of the century, and Stieglitz was one of their most vocal advocates. In the pages of *Camera Notes*, *The American Amateur Photographer*, *The Photo-Miniature*, and *Photography*, Stieglitz authored, contributed to, or included his images in numerous articles that addressed the inherent merits of these processes. Exhibitions, especially of lantern slides, abounded. When seen as important works in their own right as Stieglitz held and Newhall affirmed through acquisition, lantern slides and autochromes can provide a broader recognition of the practices of a photographer as well as his or her artistic intent. The same can be realized when comparing them with prints that depict the same subject but appear compositionally different, as in Stieglitz's "Winter, Fifth Avenue" (cat. 23, and pl. 4, cat. 20). Whether considered individually or collectively, Stieglitz's lantern slides and autochromes, of which the Eastman House holds many one-of-a-kind examples, attest to the particular character of the photographer's work. The entirety of his work found itself continually enriched by the multitude of processes, both popular and rare, that contributed to contemporary sensibilities about photography's development as a medium of aesthetic purpose.

With the benefit of additional gifts and purchases, the Museum now houses 192 photographic and photomechanical works, four cameras, and a wealth of correspondence, manuscripts, periodical titles, pamphlets, and books either by, related to, or about Stieglitz. Most recently, the establishment of the George Eastman Archive and Study Center in 1999 has contributed to the holdings with letters from Stieglitz to Eastman, and the industrialist's own references to the photographer in his so-called daybooks or diaries.

This collection catalogue, with its accompanying essays and exhibition, marks the first time the Stieglitz collection has been brought to greater public and scholarly light through publication and display. The recent relaxation of restrictions that guided the reproduction and loan of Stieglitz material acquired from O'Keeffe (see subsequent essay) provided the impetus for this important project.[4] It also afforded the timely opportunity to illuminate the intertwining lives and ambitions of Stieglitz and O'Keeffe. For each, their legacies would have far-reaching consequence for the medium of photography, including, most significantly, its ultimate acknowledgement as an art worthy of study and preservation.

[1] See David Wooters' "The Blind Man's Elephant" in *Photography from 1839 to Today* (Köln: Benedikt Taschen Verlag, 1999) for further explanation regarding acquisitions that Beaumont Newhall made for George Eastman House.

[2] Documentation at Eastman House does not stipulate the final disposition of the negatives once they were returned to O'Keeffe.

[3] These items were received in three lots, arriving in 1953, 1956, and 1959.

[4] On October 16, 1998, the Supreme Court of the State of New York granted a petition to revise conditions created by Georgia O'Keeffe, executrix of the Stieglitz estate, which restricted the reproduction and loan of works by Alfred Stieglitz. The petition was made by George Eastman House, the Museum of Modern Art, and The Metropolitan Museum of Art, with the support of The Georgia O'Keeffe Foundation, in an effort to encourage scholarly research and bring Stieglitz's work to a greater public audience.

A Voice for the Prints

Laura Downey and Therese Mulligan

After the death of Alfred Stieglitz in 1946, his second wife, Georgia O'Keeffe, took up the future of his photographic estate. Dividing her time between New Mexico and New York City, she created sets of Stieglitz's work that represented his long career and his contributions to art photography. She then disseminated the sets to American museums, attentive to the museums' cultural importance as well as their geographic locations. In her role as executrix, O'Keeffe appeared to fulfill a statement by her husband that "One does not scatter the works of Shakespeare over the face of the earth, page by page."[1] Between 1949 and 1950, initial sets from the Stieglitz estate were presented to the Art Institute of Chicago, Library of Congress, The Metropolitan Museum of Art, Museum of Modern Art, Philadelphia Museum of Art, and a key set of approximately 1,600 images to the National Gallery of Art. O'Keeffe then looked to place remaining sets, and in 1950, contacted the newly opened George Eastman House as a recipient institution.[2]

As the first American museum dedicated solely to photography and motion pictures, the Eastman House was a prime candidate to benefit from O'Keeffe's largess, made more so due to the presence of curator and noted photography historian Beaumont Newhall, a fervent supporter and friend of her late husband. In July of 1951, Newhall accepted from O'Keeffe, as part gift and part purchase, a set of eighty-seven works, including photographs, autochromes, and lantern slides. Over the course of the next decade, she would further add to the Museum's Stieglitz holdings with gifts of cameras, issues of *Camera Work*, photomechanical prints from other publications, books, and letters.

At Eastman House, as with all other institutions that received Stieglitz estate prints, O'Keeffe's involvement did not end with acquisition. With each distribution, she included a two-page document entitled "Conditions for the Care of the Alfred Stieglitz Collection." It is part of O'Keeffe's greater legacy, and one not generally known, that this document did much to further the preservation of photography in the museum context—not only Stieglitz's work, certainly her priority, but other photographers' work as well. At a time when few art museums collected or displayed photographs, O'Keeffe's conditions contained the essential building blocks of preservation care, with an astute understanding of the particularly sensitive nature of photographic materials. She sought to ensure that the sets, which she arduously assembled, be valued for their unique character of organization and remain a monument to Stieglitz's own lifelong ambitions that photography be acknowledged as a fine art, deserving of proper handling and exhibition. O'Keeffe's guidelines, which she would update in 1972, were far ahead of their time.

In the 1950s the field of art conservation was only in its infancy: very little on the subject—the care, handling, and display of collections—had been written. And still less information existed that instructed art museums on how to preserve photographs. Consequently, museums had yet to establish professional standards. For their photograph collections, museums had to draw upon their experiences with other collections of works of art on paper. However, this experience was conditional, for graphic arts collections formed only a basis for the special needs of photographs, especially the inherent challenges given their diversity of formats, printing, and mounting techniques.

As with art museums, it is likely that O'Keeffe based many aspects of her document of conditions on her experiences as a painter and graphic artist. She also benefited from firsthand knowledge of Stieglitz's handling of photographs—not only his own, but those of his contemporaries. As a final component, she had the resources of Doris Bry, her assistant at Stieglitz's last gallery, An American Place, which O'Keeffe continued operating after her husband's death. Bry figures greatly in O'Keeffe's assembly and distribution of the Stieglitz estate. In the case of George Eastman House, Bry was the primary person with whom Newhall worked in detailing the Stieglitz acquisition and its receipt. In matters of preservation Bry also played an important role, visiting the Museum on several occasions, in particular at times of further acquisitions from the estate, for meetings with Newhall.[3] Based on the document of conditions itself and O'Keeffe's written instructions that Bry serve as her "agent" and respondent to any questions concerning the document, it is most likely that Bry shared with O'Keeffe the creation of the conditions, their research, and written form.

Through the 1950s and 1960s, O'Keeffe's conditions regarding storage, handling, reproduction, and exhibition of Stieglitz material remained a harbinger of professional preservation practices for photograph collections that would come into their own in the next decade. In the 1970s, photographers' hard-fought struggle to attain for photography a status as a fine art within museums was all but won. In this they followed Stieglitz's early lead. Scholarly as well as public acceptance of the aesthetic possibilities of the medium had become widespread, with the professionalization of curatorships, the emergence of academic programs devoted to the study and practice of photography and its history, a battery of exhibitions and publications, and a burgeoning market. Keeping step with these profound changes, O'Keeffe's keen interest in preservation issues and those involving her Stieglitz contributions grew. And at no museum was her concern more momentously felt than at George Eastman House.

In 1971, the Museum became the first institution to establish a conservation department specifically *for photography*. To head this new department, the Museum hired José Orraca, who had formerly studied conservation of works on paper at the Library of Congress. An enthusiast of photography, Orraca traveled to Eastman House in 1970 to explore its vast photograph holdings, which spanned the history of the medium. Resolved to stay in Rochester, N.Y., he looked for opportunities that would allow him to continue his research at the Museum. Enter Georgia O'Keeffe. Learning of Orraca's work and his desire to make a career in photograph conservation, she subsidized his studies.[4] In part, it was O'Keeffe's support of Orraca, as well as the Museum's own preoccupation with the preservation of its collections, that led to the founding of its conservation department.

With his newly acquired expertise, Orraca was called upon by O'Keeffe to undertake a survey of the Stieglitz collections at all institutions that had received estate sets.[5] Utmost in her mind was the current condition and care of the photographic materials in light of emergent, and decidedly more professional, standards of fine art preservation. While no documentation exists, it may be surmised that Orraca's survey either prompted or supported O'Keeffe's decision to revisit her initial document of conditions. Whatever the circumstance, in 1972 she presented to museums a revised document that, while retaining many of the conditions found in the earlier text, also set new conditions that resonated with present-day and future preservation concerns.

> The photographs and photogravures by Alfred Stieglitz received by George Eastman House from myself and the Alfred Stieglitz Estate are to be known and designated as the Alfred Stieglitz Collection.

With this introduction, in language similar in form and spirit to the 1951 document, the 1972-revised document of conditions begins. In the conditions that follow, O'Keeffe and Doris Bry defined how the Stieglitz collection was to be stored, handled, reproduced, and displayed. (For this essay, excerpts from the 1951 and 1972 documents have been quoted, with 1972 revisions underlined.) In fact, the lion's share of conditions deal with matters of storage and handling—essential elements of preservation:

> The prints are to be kept in boxes of not more than 2-1/2" depth, inside measurement, and stored flat.

> Prints should always remain face up and should lie flat. They should be picked up with hands, removed from the storage box to its lid one at a time, and returned to the box in the same manner.

> The original mat should never be lifted from the print, nor should the photograph be lifted to view the verso.

> ...protective sheets may be removed by the viewer and are to be replaced.

> No books, papers, or other objects may be laid on the photographs.

> It is understood that a responsible member of the curatorial staff in charge of caring for the prints will watch at all times anyone not on the immediate staff looking at the prints, to ensure the enforcement of the conditions.

Today, fifty and thirty years after these conditions were formulated, they remain integral practices in museum print rooms, where photographs are viewed by researchers and the public. O'Keeffe further recommended that her conditions be copied and presented to viewers:

> In order to administer the conditions relating to visitors' looking at the prints more easily, it is suggested that the Conditions relevant to their viewing be mimeographed on a separate page or card, and that each person coming to look at the prints be given a copy of this page to read before being shown the prints.

Some instructions, such as washing hands and the prohibition of ink pens, appear to be very basic, equivalent to the librarian's "Shh!" Yet these simple procedures are fundamental to proper handling of photographs or any work on paper:

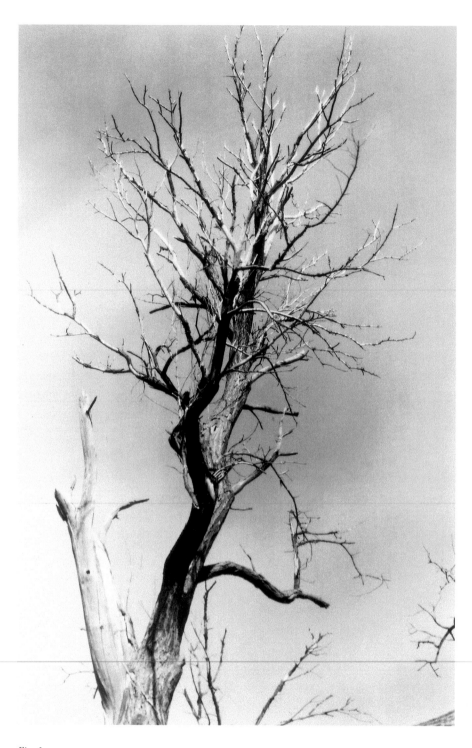

Fig. 1
DEAD TREE—LAKE GEORGE, ca. 1927
(cat. 151)

Hands should be washed before handling prints. No one is to touch the surface of the print itself, or the paper or board on which it is mounted, or the original Stieglitz mat. This means that prints may only be handled and examined by picking up the handling mats.

No pen or ink or ball-point pens or indelible pencils or comparable implements may be used on the table while prints are on it.

No marks may be added or erased on the photograph, its mount or its mat.

Implicit in the preceding conditions is a caution against errant markings or notations that would obscure or negate those of the maker and his estate administrators. With these stipulations O'Keeffe maintained the original context of the photographs, its signatures, titles, dates, and notations. In the photographs acquired from O'Keeffe, only three works bear Stieglitz's signature on the back, or verso side, of the matboard, including "Equivalent," 1925 (cat. 141). Later photographic gifts to the Stieglitz collection by Dorothy Norman (fig. 1, cat. 151) and photographer Alvin Langdon Coburn (cat. 75) carry the photographer's signature. When notations on mats or mounts do exist (see catalogue entries), they are commonly numbers and letters, written in pencil, that designate O'Keeffe's ordering of prints into particular groupings or sets. In many instances, her last name or initials appear on the back of the matboards as well. Like museums' accession numbers, these notations function as a system of organization and accurate record keeping.

As early as 1951, and reiterated in the 1972 conditions, O'Keeffe recognized the profound benefits of climate-controlled storage:

It is understood that the Stieglitz prints are to be stored properly in an air-conditioned room, if possible, to minimize the chances of deterioration.

In this she was prescient, for prior to the 1970s and the rise of museum conservation departments and related research, the impact of climate was little understood. However, as this condition states and scientific studies now confirm, the twin actions of fluctuating temperature and humidity are the primary sources of long-term damage to photographs.

Together with storage and handling, O'Keeffe included several conditions that dealt specifically with preserving the original mounting and mats of Stieglitz's photographs, as well as their subsequent presentation on museum walls. It was her goal in issuing the conditions that they be preserved in their totality, which was part of the photographer's larger legacy. The first sentence of the following conditions frames this view (see fig. 2):

Fig. 2
Robert Brown
ALFRED STIEGLITZ, 1939
Gelatin silver print
Gift of the photographer

All the prints were mounted and matted by Stieglitz. They are to be left mounted and matted as received, except for the removal of glass and frames, which is optional. They are

to be placed in rag board handling mats similar to those used by an art museum Print Department for the protection of etchings and engravings."

To guard against any future harm that might occur in handling and presentation, O'Keeffe followed this condition with more specific stipulations. These requirements demonstrate the extraordinary extent of O'Keeffe's wishes to sustain the original condition and presence of the photographs and the fastidious working habits of their maker:

A sample handling mat will be sent with the prints. The board of the handling mat under the Stieglitz mount should be one-quarter to one-half inch wider than the Stieglitz mount, and the Stieglitz mount centered in this space. The quarter-inch margin looks better that the half-inch margin, but the half-inch margin is more apt to keep finger marks off the Stieglitz mats and mounts.

In a very few instances in which the Stieglitz print is dry-mounted so that it is raised very high from the original mount, the four-ply handling mat is not thick enough to protect the surface of the print. In such cases, the handling mat must be made thicker. This can be done by cutting out a double set of mats for the handling mat, which raises the total height of the handling mat above the print surface.

Should you consider it necessary to remount or remat the photographs for the sake of their preservation, this may only be done after consultation with Doris Bry or myself, or, after our lifetimes, with a curator or conservator from within or outside of George Eastman House who has the most experience with the handling and preservation of rare photographs.

Should such remounting or re-matting be necessary, it is requested that it be done as nearly as possible to resemble the original presentation, with a rag mat of the same overall size as the original Stieglitz mat. The new mat should match as nearly as possible the color and texture of the Stieglitz mat. The opening in the new mat is to be exactly the same size and in the same position on the print surface as the opening on the Stieglitz mat....

Under no conditions may the dimensions of the mount or mat be changed.

Throughout his career, as his photography moved from a pictorialist to a modernist construct, Stieglitz employed various mounting techniques to support and enhance his current approach. The Eastman House's collection holds only a few examples of his more elaborate pictorialist mounting style, as in "Venice," 1894, a gelatin silver print, printed later, drymounted to a green-gray card (fig. 3, cat. 37). Instead, the Stieglitz collection bears out the photographer's modernist preoccupation in mounting, since the vast majority of the photographs are gelatin silver, printed in the 1920s and '30s from original negatives. Here the mats that support the mounted photographs are smooth in texture and pristine white in tone. All pictorialist devices previously in vogue, including colored and highly textured mats and mounts and tissue interlayers between print and mat, have been swept away in Stieglitz's later work for a more focused and spare presentation. No undue embellishment was allowed that would take away from the presence of the photographic *object* at hand.

Further complementing this modernist perspective was Stieglitz's choice of frames, whose armatures were narrow and profiles were extraordinarily simple in appearance. In her conditions, O'Keeffe required that museums carry out the original context of her late husband's work, either on its walls or on view in a print room:

> Prints may be framed for hanging, if this is done without changing the size of the Stieglitz mount or mat in any way....but I believe that they are best seen without glass on a table, and that they are preserved with minimal exposure to light. Frames should be simple and narrow as possible, to resemble the original Stieglitz frames.

A closer examination of the photographer's collection at Eastman House reveals a unique opportunity to study the various techniques he utilized when mounting his photographs. While it was most common for Stieglitz to drymount a photograph to a lightweight white card and then adhere the mounted card onto matboard, he often took greater measures

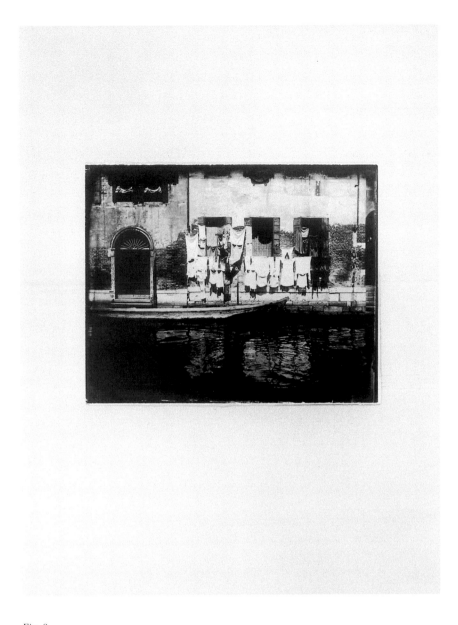

Fig. 3
VENICE, 1894/print ca. 1924–1934
(cat. 37)

to guarantee the security of the mounted photograph. In these instances, Stieglitz would first trim a print to the image size to be displayed, eliminating any border. He would adhere this print to the verso, or back, of another trimmed photograph. The recto, or front, of the print not to be shown was then adhered to a lightweight card. The card bearing the mounted two prints was subsequently fixed with rubber cement to a larger, white-surfaced mat. An example of this mounting technique is "Paula, Berlin," 1889 (fig. 6, page 27, cat. 9), a gelatin silver photograph, printed later, ca. 1924–1934, in which the photograph is mounted on the back of a discarded print of "Poplars, Lake George," 1932 (fig. 16, page 37, pl. 26, cat. 181). With this procedure, Stieglitz controlled that his prints did not curl or come loose at the edges of the mount.

In adhering his prints to their mounts and matboards, Stieglitz used techniques familiar to him and his contemporaries. Drymounting prints to either cards or matboards was commonplace and offered the best technique for securing the entirety of a print to a support. Less beneficial, but unrealized at the time, was the use of

rubber cement adhesive, which consists of natural rubber, usually vulcanized, dissolved in an organic solvent. It was Stieglitz's habit to employ this kind of adhesive when mounting a card onto matboard. Although the photograph, mounted atop the card, did not come in direct contact with this potentially harmful material, the card as the photograph's primary support did. The consequence for prints mounted in this way has proven a challenge. Rubber cement adhesives harden over time, reducing their ability to serve as an anchor between the photograph's mount and matboard. Thus, the likelihood of separation is greater; the damage to the photograph a constant threat. At Eastman House, minor mount repairs to the collection, involving safer and more permanent adhesives such as starch paste, have been an ongoing preservation activity by the conservation department.

Fig. 4
EQUIVALENT, 1923
(cat. 134)

While the quality of matboard in the Stieglitz collection varies from work to work, the majority of prints are mounted on good quality rag mats, containing a proper percentage of cotton or a mixture of cotton and flax fibers. A good quality rag matboard assures not only the stability of a mounted print, but its longevity as well. In the instances where a rag matboard of the highest quality was not selected, the signs of the board's deterioration are evident, including yellowing and brittleness due to aging and the assault of acidity. At the Eastman House, the matboard upon which Stieglitz's "Equivalent," 1923 (fig. 4, cat. 134) is affixed suffers from these aspects of deterioration. But thanks first to Stieglitz's working habits, and later O'Keeffe, whose conditions stipulated that museums use only the highest quality rag matboard when handling or displaying Stieglitz photographs, the collection has been well preserved. It is interesting to note that, beyond her conditions, O'Keeffe had a greater hand in preserving the stability of the photographs, when she and Bry remounted numerous prints to matboards before sending them on to their new institutional homes. In the Eastman House collection, four such works are known to exist: "Georgia O'Keeffe", 1918 (pl. 28, cat. 112), "Dorothy True," 1919 (pl. 15, cat. 115), "Dorothy True," 1919 (fig. 5, pl. 14, cat. 116), and "Clouds, Music No. 1," 1922 (fig. 6, pl. 24, cat. 123). These are the same works that O'Keeffe asked the photographer and Stieglitz's contemporary Edward Steichen to treat for deterioration.

Fig. 5
DOROTHY TRUE, 1919
(pl. 14, cat. 116)

Ever the ardent experimenter, Stieglitz was a constant advocate of a variety of photographic printing methods, ranging from photogravure

Fig. 6
CLOUDS, MUSIC NO. 1, LAKE GEORGE, 1922
(pl. 24, cat. 123)

(fig. 7, cat. 100) to gelatin silver, lantern slide transparencies to platinum (see catalogue entries). For him, as with many of his colleagues, each method brought its own particular stamp of appearance, one that supported the aesthetic character of an image. As part of his explorations, Stieglitz produced numerous works in palladium, including those works cited above. Similar in appearance to a platinum print, a palladium print has a matte surface and subtle tonal gradations. The image of a palladium print is embedded in the fibers of the paper support, not suspended on its surface as with gelatin silver photographs. The palladium process involves a sheet of paper sensitized with iron salts and exposed in contact with a negative until a faint image is formed. In development, the iron salts are replaced with palladium, and the image becomes more pronounced.

While organizing the estate for distribution, O'Keeffe recognized that many of Stieglitz's palladium prints suffered from excessive yellowing. In the late 1940s, she asked Edward Steichen, whose knowledge of unique printing methods was extensive, to attempt to reduce and arrest this deterioration.[6] Steichen was the natural choice for O'Keeffe to turn to for assistance, as at the time there were no conservators or museum professionals

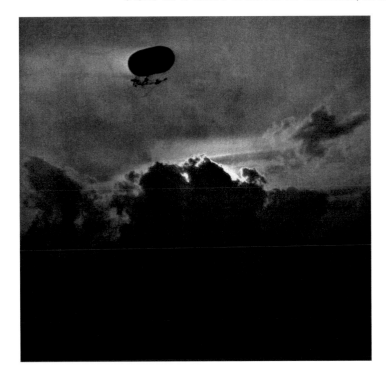

Fig. 7
THE DIRIGIBLE, 1910/printed 1911
(cat. 100)

who specialized in such treatments. Instead, only experienced practitioners, such as Steichen, well versed in this method, were equipped to provide any kind of remedy. However, in retrospect, the remedy that Steichen chose to treat Stieglitz's palladium prints may have done more harm than good.

Conservators at museums that received palladium prints from the Stieglitz estate, including Douglas Severson, Art Institute of Chicago; Constance McCabe, National Gallery of Art; and the conservation staff at Eastman House, have long sought to understand Steichen's treatment. Hindering their progress has been Steichen himself, who did not leave any documents detailing his treatment. Fortunately, Doris Bry identified these works with a pencil notation on the matboards. This procedure has provided conservators with a first line of inquiry when comparing untreated palladium prints to those treated by Steichen. Their findings have shown that both treated and untreated prints display a similar consistency of yellowing, although the treated prints appear lighter overall. They have also found that treated prints often have a rougher paper texture than those untreated. Conservators theorize that Steichen's

treatment may have involved an aggressive use of paper bleach, a technique that Severson advises "may have a heightened susceptibility to physical deterioration, such as surface cracking or weakening of the paper support."[7]

Such research has led to better guardianship of Stieglitz collections around the United States and a better understanding of their future preservation. This has become especially important in light of the recent relinquishment of O'Keeffe's conditions that the Stieglitz prints not be loaned at any time to any person or institution, and when exhibited at their home institutions, they be hung only in two-year intervals. Recognizing when she first devised these conditions that art museums had little experience in exhibiting photographs, O'Keeffe sought to stem the harmful effects the photographs could incur with excessive handling, display, and light exposure. While her concerns may appear conservative today, when conceived they demonstrated a foresight and a respectfulness that photographs are first and foremost temporal objects and can be unduly affected by exhibition or travel.

As the "voice" of Stieglitz and his work, O'Keeffe's document of conditions is, on one hand, rightfully understood as a pronouncement of the photographer's important legacy to photography, its practice, and history. On the other hand, and more importantly, its lasting effect has set standards of preservation to which today's caretakers—conservators, archivists, and curators—continue to aspire.

1. Richard Whelen, *Alfred Stieglitz* (New York: Little, Brown and Company), 1995, p. 574.

2. See the introductory essay for further information regarding the Museum's acquisitions to the Alfred Stieglitz collection. The San Francisco Museum of Modern Art received their set of images in 1952.

3. O'Keeffe to Newhall in letter dated November 16, 1965.

4. José Orraca to Laura Downey, March 31, 2000.

5. *Ibid.*

6. Douglas G. Severson, "Alfred Stieglitz's Palladium Photographs and Their Treatment by Edward Steichen," *Journal of the American Institute of Conservation* 34 (1995): 2

7. *Ibid.*: 8

O

Eugenia Parry

h, how Americans have wanted heroes, wanted brave simple fine men!

—Sherwood Anderson

Stallions and Geldings

I once saw two teams of black stallions pulling wagons, going along side by side. The traffic was

stopped. The horses were lined up in front of me. Along the curb were many women at market.

The horses stood there, throbbing, pulsating, their penises swaying half erect—swaying—shining.

I stood...transfixed, regretting that I had no camera with me. No one wished to be seen looking

at the animals, yet one could feel that everyone was aware of them, wanting to look. In New York

such a thing would not be permitted. All the horses in the city are geldings.[1]

Alfred Stieglitz was in Paris. Pierced by the vision of four sweating stallions, penises distended—he speaks as

if from the troubled shadows of a waking dream. He had no camera, yet his account encapsulates the event into

a virtual photograph. Everything is vivid and complete: his closeness to the animals—eyes glaring, nostrils flaring,

flanks throbbing; his acute awareness of the state of the embarrassed women trying to maintain their propriety.

Could anyone have recorded, with a hand-held camera, such physical and psychological intricacy and extract

a picture that expressed it all? Unlikely, in Stieglitz's time or any other. The scene was for his memory alone, a

kind of fairy tale destined for retelling. Like great epiphanic moments, lost by street photographers universally,

it is a variant on the fisherman's story of the one that got away.

Stieglitz knew horses and loved them. Before the motor car, they were as common as sidewalks. But for Stieglitz

horses always held a deep personal interest. From childhood he'd devoured racing histories and with his playmates

restaged the triumphs of the turf, using miniature jockeys and horses made of wood and lead. These historical

meets had a preordained outcome. Alfred called the shots, directing great winners—Waterboy, Sysonby, and

Man o' War—to the finish line.

At age nine he accompanied his father, an admirable rider, to the Saratoga races to watch real thoroughbreds

in action. The privilege had been important in allowing the boy another kind of closeness to his parent through

a spectator sport they both enjoyed. As an adult, when he observed that everything vital in city life seemed to be eroding into a sterile "mechanical civilization," for Stieglitz the racetrack retained a residue of all that was wild and archetypal.

He was crazy about racing. Compared to the rarefied atmosphere of modernism in his galleries, the track, noisy, bright with silks, milling spectators, and an underworld of gamblers "with big diamonds on their fingers or in their neckties,"[2] was a vulgar contrast—odd asylum for an American seer. Georgia O'Keeffe enjoyed the contrast.

> When he really wanted to give himself a treat he went out and bought himself a book on racing horses....He always followed the races. The sporting page was the first part of the paper he looked at every day.[3]

To Stieglitz thoroughbreds were the ultimate of animal achievement, the most magnificent creatures on earth. Writing about him as a photographer, Lewis Mumford included the race horse (along with the sky, trees, and woman) among the dominant symbols of Stieglitz's personal and artistic life. The horse, Mumford said, was the equivalent of animal vitality as woman was the symbol of animal spirituality.[4]

What is a horse race but a linear trajectory in space that suddenly explodes at one point, finishing with equal excitement at another? Following the flow of animals speeding along the track, the distant spectator, binoculars to the face, concentrates on outlines, impressions, externals. Fixing on a line of sight, looking neither left nor right, he is compelled to follow a plane. For Stieglitz photography itself was such an exercise in the transposition of action to flatness.

But Stieglitz never photographed the fierce, primitive qualities of the sport or the thoroughbreds he admired. Mumford apologizes:

> Stieglitz was too near the race horse, as one is too near the lover in an embrace to be able to photograph him. And yet the horse symbolized to him...something essential in the life of man: [something]...he had too lightly turned his back on and renounced in his new mechanical preoccupations.[5]

Like the Paris incident, photographing horses in a manner that would convey their power over his imagination remained an unfulfilled wish. Dorothy Norman wrote that Stieglitz had "dreamed" of doing a sequence of photographs devoted to geldings and stallions,[6] but it never materialized. Mumford understood the project differently.

Stieglitz conceived, though he never carried it out, a series of photographs of the heads of stallions and mares, of bulls and cows, in the act of mating, hoping to catch in the brute an essential quality that would symbolize the probably unattainable photograph of a passionate human mating.[7]

A grandiose scheme, but Stieglitz didn't need such symbols to photograph human sexuality. He found this directly in his extended portrait of Georgia O'Keeffe (cat. 111, et al.), the Lake George pictures of Rebecca Strand (cat. 125; pl. 17, cat. 127), and especially of Ellen Koeniger (pl. 16, cat 110), which have a wild, "out of the swamp authority."[8]

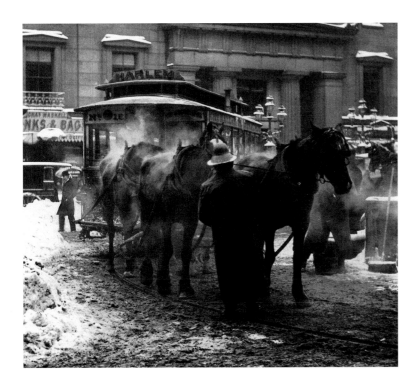

Fig. 1
THE TERMINAL (NEW YORK), 1893
(pl. 5, cat. 16)

Perhaps he photographed aspects of the races. Mumford cites "the fine print of Going to the Post,"[9] but other images haven't surfaced.[10] Evidence of Stieglitz's attraction to horses lies in pictures unrelated to the excitement of the track. When he walked the New York streets in the 1890s he saw horses pulling carriages, hansom cabs, and tram cars. He documented them not as lesser versions of the animals he loved, but, acting as a tourist in his own city, he blended these work horses into a texture of the picturesque.

For "The Terminal (New York)," 1893 (fig. 1, pl. 5, cat. 16), he fixed his camera on four standing horses hitched to a Harlem streetcar. Far from what Paris had to offer, these New York geldings were old and weary. In the cold air, steam from their bodies obscures whatever vital beauty they may have possessed, as does the figure of the man in the waterproof coat whose back obstructs access to them. Stieglitz said the man was watering the horses. The image doesn't show it. Nothing we can see verifies what became, on future reflection, the most significant act in the picture. He said that there seemed to be something related to his "deepest feeling" in what he saw. Lonely in his own country, he felt grateful that the poor horses had someone to give them what they needed.[11] The words don't explain his distance. They cloak the snapshot in self-pity.

Stieglitz wrote of his suffering to achieve "Winter—Fifth Avenue" (fig. 2, pl. 4, cat. 20). It was "the result of...patient waiting,...a three hours' stand during a fierce snowstorm on February 22d, 1893"[12]—until he discovered "the living moment"[13] and chose to click the shutter. But the four horses pulling the coach, caught in a drama as they pressed northward against the raging wind, are nothing more than bit players in an impressionistic blur. Stieglitz didn't confront these horses whose plight in blinding snow ought to have elicited the sympathy he felt for those at the terminal. He stayed too far away to see their frozen sweat or smell their blood.

The view is dominated by wheel tracks in boulevard slush. He was photographing weather, against all odds. For that reason the picture won many prizes. It was widely exhibited and reproduced so that other photographers could emulate what was clearly a technical triumph. They did. In camera clubs at home and abroad, snow scenes became the vogue.

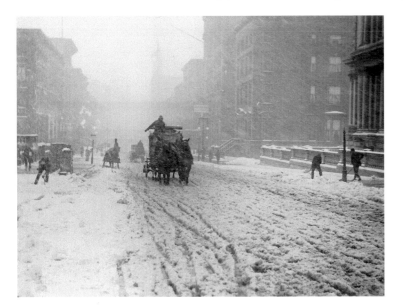

Fig. 2
WINTER—FIFTH AVENUE, 1893/print ca. 1924–1934
(pl. 4, cat. 20)

Other city pictures with horses impart a similar lack of consequence to the animals. In "Excavating—New York," 1911 (fig. 3, cat. 102), horses hitched to wagons are no more significant than human workers. All are tools in a larger enterprise, equal to the crane and its bucket of debris. Only in "The Street—Design for a Poster," 1896 (cat. 62), did Stieglitz let the horse express feelings. Again, distancing the animal, the photographer was satisfied to profile its heavy belly and lowered head against the avenue of trees, pedestrians, and parked cabs. Through silhouette alone the New York gelding declared its age, misery, and exhaustion.[14]

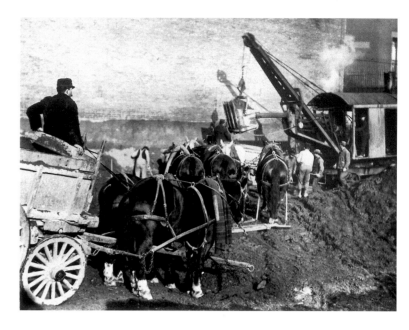

Fig. 3
EXCAVATING—NEW YORK, 1911/print ca. 1924–1934
(cat. 102)

What made Stieglitz, for whom horses, like many subjects, were some version of himself, consign the beloved creatures to picturesque and psychological oblivion? Perhaps he wasn't experienced or bold enough to extract from them the exuberance of the Paris stallions. In 1923 Stieglitz, age fifty-nine, with plenty of experience, made a queer horse picture: the animal was white, castrated, and hitched to a harness. This time he got close to the hind quarters. With his camera he peered under the belly to focus on the sheath that hid the horse's penis.

He called the picture "Spiritual America" (fig. 4, cat. 129). The intention requires no explanation. It reflects Stieglitz's eternal need to teach.

> When I am moved by something, I feel a passionate desire to make a lasting equivalent of it, but what
> I put down must be as perfect in itself as the experience that has generated my original feeling of having
> been moved.[15]

But this horse picture is as reticent as the others. Getting close has the same effect as distance. Both succeed in blunting his original feeling. Focusing on the straps and chains of the harness, Stieglitz gives them too much tactile prominence. Flank and belly occupy three-quarters of the format, the segmented flattening geometry of which offers its own visual distraction. Considering the title of this icon of modern resignation, the genitals are crucial. Stieglitz had observed that in New York geldings were the norm. The horse's sheathed penis represents not only America's plight, it seems to stand for the photographer's own frustration in recording his passion. He hid the bafflement. The horse's penis in "Spiritual America" is practically invisible.

Fortress of The Word

The cult of Alfred Stieglitz is one of American photography's more notable artistic muddles, the source of which is none other than the man himself. The verdict would have irked him, for he directed his life as if to defy such pronouncements. Yet today, as one observer states the conundrum, "Stieglitz is famous, but his work is little known."[16]

Fig. 4
SPIRITUAL AMERICA, 1923
(cat. 129)

Stieglitz made some admirable photographs. They don't reflect what nearly sixty years of dedication to art and camera work might have promised. "No other major figure of photography's modern era is known by so short a list of pictures."[17] Whatever their number or quality, Stieglitz's pictures are not what distinguish him throughout the world. He loved photography. But it was never enough.

With boldness and unprecedented zeal, Stieglitz assumed a greater burden. He fought for modern art as practically no one else did in his time. Even to those outside photographic circles, his campaign still carries an aura of near-sacredness in the American experience. He was fond of repeating that the mission was a martyr's sacrifice, nothing less than the impossible task of teaching America to see.

To the young Stieglitz, America's surrender to materialism had made it a decadent place. After experiencing European high culture as a student, he returned to New York, worried: the wasteland had hardly anything worth looking at. America needed the spiritual and moral resuscitation that comes from viewing great art. Modern European masters—Cezanne, Rodin, Matisse, Braque, Picasso—could guide people toward appreciating the rewards of visual intelligence. He would import and exhibit the work of these artists in his galleries at his own expense. He would encourage, if not goad, young American painters—Marin, Hartley, Dove, O'Keeffe—into celebrating America's peculiar contradictions. He would support their work as if his life depended on it.

Stieglitz's battle, in the first decades of the twentieth century, mostly failed to change his country's visual habits. But his fight for photography, which lacked a respected place in the cultural hierarchy, succeeded beyond measure. The machine age may have repelled and amazed him by turns, but he saw that camera machines, directed by workers of "applied intelligence," could produce pictures of "brutal directness,"[18] as beautiful as any others, legitimate forms of personal expression, worthy of museums, of being mounted and handled with the same reverence as Old Masters.

A gifted technician from the outset, Stieglitz conferred aesthetic properties on certain cameras, lenses, and on selective framing. He made an art of the lantern slide (fig. 5, cat. 45). He explored his dedication to the subtleties of photographic printing by rendering subjects, variably and often beautifully, in silver, platinum, and gravure. Thus he expanded camera work beyond mere recording with the additional hope that it might become something entirely new. He decided that photographing could be a soulful exercise, not only for others, but for himself.

Stieglitz liked to boast that in accomplishing these aims he had no credentials, no training in painting or drawing. He had to invent his own ABCs. To become credible as a photographer, he entered scores of competitions, winning his first prize at age twenty-three. "He seems to have done very well, as there are boxes and boxes

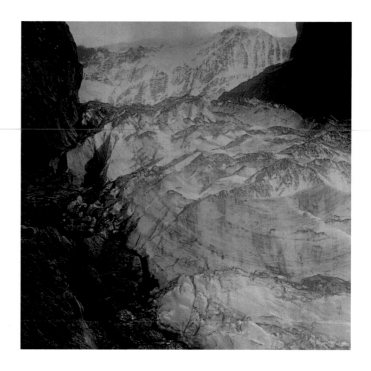

Fig. 5
GRINDELWALD GLACIER, 1894
(cat. 45)

of them, photographic medals from everywhere."[19] The recognition gave him what he needed, a requisite pedigree for judging others.

Stieglitz's aesthetic standards were initially formed by the taste of his father, an amateur painter, who hung the walls of the family dwellings with dark, syrupy mystifications by lesser nineteenth- and twentieth-century German romantics and their followers, some of whom were personal friends. Franz von Stuck, the German-Secessionist painter with a taste for Wagnerian excess, was one of Alfred's favorites.

For nearly twenty-five years, the New York apartment that he shared with his first wife, Emmeline, and daughter Kitty, had the dour flavor of his father's rooms. Each morning, when Stieglitz left home for his gallery of modernism, he turned his back on the nineteenth century's dark cloud for the gray-walled minimalism of the twentieth, returning at night to nineteenth-century shades. Not a few noted this dualism. The art reformer ignored the contradiction, concealing doubts he or others might have had about his clarity with strong opinions, extravagant exaggeration, and an eldest son's habit of dominating. From photographic judge he became an arbiter of modernist taste. More than this, he became an oracle.

Oracles' utterances may be puzzling, but traditionally they are infallible. Stieglitz's kept shifting, depending on whose work he happened to be studying at the moment. Frank Eugene, with whom he would explore the autochrome process, at first was "the sloppy fellow with the black fingernails, I don't want him to come to my house"—until Sadakichi Hartmann persuaded him that Eugene was quite a good photographer.[20] Mostly, Stieglitz strangled dissent with a "ribbon of talk...strong as a cable."[21] His truths of the moment had absolute authority.

In this atmosphere many young artists and writers, desperately seeking sanctuary in his presence at the Little Galleries of 291, The Intimate Gallery, or An American Place, found themselves reduced to idolatry. They willingly relinquished their truths to his definition of their task—"Stieglitz is for those who dare,"[22] declared the partisans. Sherwood Anderson "gratefully dedicated" the first of his three autobiographies, *A Storyteller's Story,* 1924,

To

Alfred Stieglitz

who has been more than a father to so many puzzled, wistful children of the arts in this big, noisy, growing and groping America,....[23]

Anderson calculated his book to place himself among the leading writers of his time. In this melancholy, self-abnegating tribute the writer remained his master's wistful child.

To the young art teacher Georgia O'Keeffe, Alfred's decrees, at first, must have seemed like a paradigm for quality.

I believe I would rather have Stieglitz like something—anything I had done—than anyone else I know of—I have always thought that—If I ever make anything that satisfies me even ever so little—I am going to show it to him to find out if its [sic] any good—Don't you often wish you could make something he might like?[24]

After his death she safely declared that what he thought contained a "good deal of contradictory nonsense."[25]

Walker Evans's meeting with the man led him to concur with the vehemence of someone all but ignored: "He should never open his mouth. Nobody should, but especially Stieglitz."[26] Why? Because the oracle's "vast circuitous monologues," "plastic," and with the "organic dimensions of a page from Dostoievsky [sic]," not only lacked literary craft but verbal coherence.[27] Yet the great talker effectively destroyed anyone who didn't side with him. As far as he was concerned, the poor dissenter hadn't existed in the first place.

The Stieglitz family were prosperous German Jews who loved excellence in all forms—thoroughbred horses, Wagner, Goethe. Pater familias Edward Stieglitz, cloth merchant, amateur painter, connoisseur, and sportsman, managed to become the only Jewish member of the New York Jockey Club. Familiar with the ever-present threat of exclusion, the Stieglitzes emulated the enemy by turning tyranny into another of their parlor games. Edward, a "short fuse," was so sensitive to noise that a dinner guest recalls fearfully swallowing whole an almond he'd put into his mouth to avoid expulsion from the dining room should his host detect the irritable cracking sound.[28] Brother Leopold was supremely comfortable expelling Alfred's wife, Emmy, from the family circle during an argument: "I am the son of the house, who are you?"[29]

This style defined Alfred's own. He turned it into a mythos of generous *inclusions* regarding whom he decided to exhibit or write about on the pages of his beautiful magazine *Camera Work*, or whose paintings he purchased for his own collection, or which painters' working lives he literally paid for. Yet he blackballed those who didn't fit in, scotching for *Camera Work* a piece on Odilon Redon, the French visionary, known to have mused that thinkers prefer the shade. Stieglitz kept those who wouldn't conform to his "life"[30] view of art from the walls of his gallery shrines or drove them from the premises.

Even for those who loved him, and there were many—"the sweetness of the man is the thing to take hold of"[31]—what he said, or is remembered to have said, was all that mattered: "That is it. You've captured life," he erupted at poet Hart Crane. Crane was happy, but exactly what was meant remained a benign blur.[32] Intimates risked annihilation by crossing him: O'Keeffe recollected that she wouldn't have survived as a person or as an artist any other way.[33] Breaking rank, however, she wasn't as threatened as she suggested. Stieglitz's vision, linear and deterministic, distinctly contrasted with her "emotional forms quite beyond the reach of con-scious design, beyond the grasp of reason."[34] In his enthusiasm for her work, he might have tried to impose his standards, but he never touched the depth or extent of her intimism, which explored the interior life of things, and while she lived with him, remained her secret business.

When Stieglitz wasn't spouting opinions in "a constant grinding like the ocean,"[35] he was writing them down[36] or commandeering supporters to do so in *Camera Work* and many other publications. Asked to describe in the magazine what 291 meant to him, the surrealist Man Ray confessed that with each new visit to the gallery he felt "pleased," "surprised," or "sometimes hurt." He didn't explain. Instead, he conjured Stieglitz as a force, but one needing to live through others:

A Man, the lover of all through himself stands in his little gray room. His eyes have no sparks—they

burn within. The words he utters come from everywhere and their meaning lies in the future. The Man

is inevitable. Everyone moves him and no one moves him. The Man through all expresses himself.[37]

The writers' gifts for praising and explaining ran the gamut, from Man Ray's studied vagaries to razor-sharp

perceptions in superb essays on every subject that could be related to Stieglitz's modernist program, by Sadakichi

Hartmann, Charles H. Caffin, Paul Rosenfeld, and Paul Strand. There were Lewis Mumford's sexualized ramblings,

Waldo Frank's mystical ravings, and panderings by Jean Toomer, Harlem Renaissance writer and slavey to the Lord

of The Hill at Stieglitz's Lake George house. Gertrude Stein, writing about the magus, sounds less like the genius

Stieglitz imagined she was than an addled hop-head. Equally hypnotized, Dorothy Norman saw clairvoyance and

prophesy. In Norman, O'Keeffe saw "a mouthful of hot mush."[38]

The continual re-explanation of Stieglitz's life and work as hallowed destiny resembles the veneration of texts

through constant analysis in Talmudic study. "His ways are near to the old ways of his people," Waldo Frank

swooned of his "prophet" and "Jewish mystic."[39] Like the layered exegesis and digressive, devotional hair-splitting

in rabbinical argument, Stieglitz's relentless collective portrait remains less a history than a fortress of The Word.

I never thought much of myself as a Jew or any other particular thing. But I'm beginning to feel it must

be the Jew in me that is after all the key to my impossible make up.[40]

The impossible make up became a fable of endless guises, each claiming to have grasped the master's tortured

complexities. In its time this literature was a marvel of completeness. It remains unique in writing about, or related

to, any photographer, past or present. But the repetitions feel increasingly suspect: grandstanding obscures.

The situation has led to a peculiar stagnancy that infects more recent accounts of Stieglitz's life and work

by students of modernism who ought to know better and persists without evident relief. Adding more detail,

most of these accounts maintain the story virtually intact. Stieglitz may have been "notoriously insensitive

to the feelings of other people,"[41] but he "remains as one of the most dominant individuals in the history

of photography."[42] Here the muddle clarifies: seeking to uphold American photography as progenitor of all

that is photographically superior, this chauvinism confuses a dominant individual with an artist. It also con-

founds the cultural debt Americans feel toward Stieglitz with conclusions about his artistic superiority.

What kind of a photographer/artist was the man who couldn't stop talking, who all but buried his own gifts

in high-flown intentions? Regrettably, some attempts to flood the unassailable monument with fresh air some-

times suffer from unflattering innuendo,[43] the aggression of which offers welcome comic relief, though Stieglitz's

conduct as reformer or photographer rarely amused. Pious seriousness is guaranteed to tire those for whom

absolutism lacks glamour. O'Keeffe would feel the pall, sighing at the end of a long life, "I'm bored with my

history, my myth." To which recent scholars are rallying with, "So are we,"[44] and have begun the process of

enriching our knowledge of her artistic evolution by organizing and astutely reexamining her paintings.[45]

Stieglitz experienced similar ennui, which took the form of physical and psychological illnesses, feigned or real, and ultimately led to exhaustion with practically everything. Predictably, he dramatized one such admission with an exercise in pyrotechnic destruction.

> A year ago in Lake George I burnt up negatives, prints, over 1000 copies of *Camera Work*, including a complete set—nearly a library of books—just to get rid of things. It was a great sight watching all these things disappear into the starlit night. I'm still in the ring—ever the damned Fool but alive.[46]

The "damned Fool" needed to hear truths other than his own, but few dared confront him. He was doing so much good. Promoting modern vision and midwifing careers was a full-time job. Indisputably important, Stieglitz's sacrifices for others also might have been easier to undertake than those he needed to make for himself, less threatening than the solitary uncertainty of his own creativity. Doomed to judge, he trapped himself in expectations for his photographs that he may have felt incapable of meeting.

Many generously attribute the fact that he photographed so intermittently to the toll of his crusade. By 1910 he was referred to as "a former photographer,"[47] a statement that would have mortified him. But years passed without many pictures. Telling others what to do was a drug that overstimulated his mind. Where was the silence within that urges artists forward? Stieglitz masked the disparity with an ego as big as the Ritz, confessing to Walker Evans, "I would have been one of the greatest painters ever born, had I painted."[48] Reporting with a certain horror, Evans admitted that the revelation gave him something to think about. We may extract the implication that having photographed, however sporadically, Stieglitz, like the rest of America, considered himself one of the greatest *photographers* ever born.

Hierarchy

There is a perplexing discrepancy between Stieglitz's celebrated role as self-appointed champion of modern causes and the photographs he produced. Despite what he said, plenty of visual evidence shows that he was less secure photographing than promoting others. The process of sorting this through has only begun. The exhibition that accompanies this book represents a lifting of restrictions that, until recently, prevented greater access to the pictures. After Stieglitz's death, O'Keeffe unwittingly all but hid his work to guarantee it the museum protection she felt her husband would have wanted and that she believed the totality of images deserved.[49]

As more people view the photographs without prior knowledge of the Stieglitz legend, new opinions undoubtedly will surface. The veneration that Stieglitz engineered will join the tortuous corridors of history, and the artist will stand or fall on his own merits. The risk is enormous, for we are bound to learn something new in dealing with him not as the renowned reformer, but exclusively as a photographic amateur and consummate experimentalist.

To examine Stieglitz's works, not as automatic masterpieces, but as examples of unresolved, and at times, inexpressible feelings, forces us to reconsider the relations between his intentions and their visualization in images that he needed to justify so lengthily. We must reconnect them to what surrounded their making,

not the least of which after 1916 was the constant presence of Georgia O'Keeffe. Her paintings and opinions about art, photography, and what his pictures meant to her still haven't been meaningfully integrated into writing on Stieglitz.

To experience renewed scrutiny, and perhaps thereby to accept another place in the artistic hierarchy, is one of the most interesting, if not painful, things that can happen to an artist. In Stieglitz's case this process is complicated, maybe even enhanced, by the fact that the hierarchy itself is radically changing.

Criticism and histories of art and photography are ceasing to be studies of masterpieces. The visual pluralism of our information age, gaining momentum during the nearly fifty years since Stieglitz's death, has led to interest in all kinds of camera-generated pictures, many never intended as art in the traditional sense. Some of these are revered for their eloquent beauty as they testify to how cultures, groups of people, or individuals thought, imagined, self-advertised, explained, remembered,—[50] or even failed to fulfill their aims.

Suppose that Stieglitz fits into this latter category. He intended his photographs as works of modernist art, constructs that were often cool and spare. No matter how automatic a process may seem, images emerging from it betray, for better or worse, not only a specific style, but all that a photographer has to give. When American painter James McNeill Whistler responded to attacks regarding the insubstantiality of his nocturnal mists, he declared they contained "the knowledge gained through a lifetime."[51]

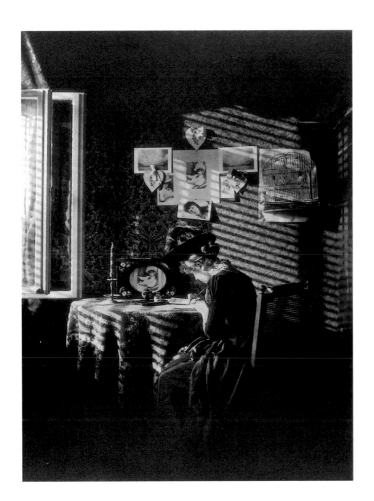

Fig. 6
PAULA, BERLIN, 1889/print ca. 1924–1934
(cat. 9)

Compared to the work of his contemporaries here and abroad, Stieglitz's photographs "ever born of an inner need— an Experience of Spirit,"[52] often lack this "Spirit." Like Whistler, he may have brought to their making the knowledge gained over a lifetime, but as someone afflicted with a malady of over-thinking everything he was about to do,[53] what Stieglitz actually accomplished regarding "Spirit" was rife with conflict. To under-stand his peculiar creativity we must confront this conflict and study all of its manifestations.

Amateur

To those viewing American photography from outside American circles, notably Europe, and particularly France, Stieglitz's camera work does not always command the admiration that viewers from his own country seek to grant it. Many find the pictures merely pleasing exercises by an intelligent amateur.[54] If his technical profi-ciency is commendable, it never attained Steichen's ecstatic experi-mental freedom.[55] Stieglitz's autochromes avoid the glorious spectrum of hues promised by the Lumières' process (pl. 10, cat. 83), which Steichen's autochromes fulfilled and Heinrich Kuehn's

elaborated into virtual dream spaces. Stieglitz treated color as a form of black and white enhanced with tasteful tints. From the outset his exploration of the language of the camera was not particularly daring.

"Paula, Berlin," 1889 (fig. 6, page 27, cat. 9), classic early Stieglitz, shows his student room where a woman sits writing. Light rays enter through window blind slats, the pattern of which animates a conventional glimpse of everyday life. The stage-like box, darkened in the corners, conjures German Biedermeyer paintings' staid derivations of Vermeer's invasive light to reveal women's silent preoccupations. Paula undoubtedly was an intimate, but in this tableau-vivant she is a mannequin, wearing indoors a hat meant for the street. Her personal qualities are mute, despite oblique references to her face in small images that decorate the desk and far wall. Stieglitz directed her as Victorian or impressionist painters did when exploring a moment of transitory light on objects.

Fig. 7
ON THE DYKES, 1894
(cat. 50)

The honeymoon snapshots of Europe in 1894 display similar emotional demurral (see fig. 7, cat. 50). They are naturalistic, that is, pictorialist, as photographer and theorist P. H. Emerson used the terms to explain desirably artistic photographs. Stieglitz is Emerson's acolyte in these airy souvenirs. Still the student technician, he is trying to decide "the amount of a landscape to be included in a picture," which is "far more difficult to determine than the amount of oxidizer or alkali to be used in the developer."[56]

Calling a set of urban views from the early 1890s *Picturesque Bits of New York*, Stieglitz declared his limitations. As with the horses he loved, he did not penetrate to the soul of the city he spent so long observing. Like a camera club aficionado, he captured only bits of local color. The pictures preceded by "five years"[57] Eugène Atget's nosings along the walls and cobblestones of Paris, but they rarely approached Atget's deeper, more intricate urban engagements.

In 1902 Stieglitz photographed an iron horse—a locomotive in a New York rail yard, some twenty-five years after Monet had exhausted the atmospheric possibilities of modern industry at the Gare Saint-Lazare. This camera image also bears the painter's stamp. That the photographer titled it "The Hand of Man" (fig. 17, page 38, pl. 6, cat. 70) suggests adherence to literary panegyrics equal to the salon rhetoric of paintings that impressed his father. In "The Hand of Man," Stieglitz seems to praise human ingenuity in industry. Or is he deploring it? Either seems possible. Monet, all eyes, avoided such commentary. France was changing; he recorded this as a series of stunning optical exercises. As he did later in "Spiritual America," here Stieglitz marshals our feelings, but the title is confusing. Without it is simply Monet's impressionism, without color.

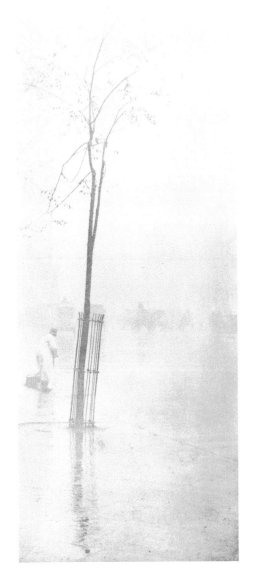

Fig. 8
SPRING SHOWERS, 1901
(cat. 68)

Impressionism is a staple in other New York street pictures as well. In "Spring Showers," 1901 (fig. 8, cat. 68), the tender "japonism" is Whistlerian. An emphatic vertical format suggests conventions of Japanese seasonal greeting cards. The inclusion of a street sweeper near the young tree recalls Paul Rosenfeld's praise for the photographer's celebrated empathy with the working classes, "sturdy, responsible, earth-fast common men whom Stieglitz to his joy has discovered at their work in the pretentious city."[58] Recall the raincoated man in "The Terminal," the driver of the four-in-hand coach in the Fifth Avenue storm, the laborers in "Excavations, New York." But the sweeper in "Spring Showers" isn't prominent enough to turn the seasonal evocation into a report on how the other half lives.

With the hand-held camera Stieglitz knew he could record what he called a feeling about life. Instead of letting his instrument take feeling to its expressive limits, he made the camera a problem, wondering instead whether the button pushers weren't photographing by the yard in a hit-or-miss sort of manner he deplored in any attitude. Victim of his standards, he pondered this, as French prodigy Jacques-Henri Lartigue used the hand-held camera to discover, with comet-like explosiveness, stunning visual fictions that momentary time declared were not only witty and undeniably true, but resembled nothing painting or photography had ever achieved.

"To Stieglitz it was less admirable to learn than to have always known...."[59] Advantageous for an oracle, fatal for an artist. Besides, Stieglitz hadn't known some rather important things. Like many Americans of his time, he was relatively ignorant of photography's early history and the range of work produced in Germany, England, and France before the epoch of photo club amateurism when he took up the camera. He had seen photographs by Talbot and Julia Margaret Cameron, but their pictorialist precedent didn't seem to inform him that the way a photograph should look, vis-a-vis painting, had been debated from the moment photography was born and lengthily thereafter. This wouldn't be held against him had he not been a dictator for whom partial knowledge was sufficient. Half-knowing, he wore himself out re-staging battles already fought and won.

Some confound Stieglitz's support of younger photographers with his "generosity" in being able to learn from them.[60] We must crack the myth and determine what and how Stieglitz learned. "The Steerage," 1907 (fig. 9, page 30, pl. 8, cat. 88), was prescient of Picasso's or Braque's cubism, but Stieglitz printed the image for *Camera Work* only four years later when others pointed to its extraordinary abstraction.[61] The "Equivalents," in the early 1920s, revived his hope in photography as a soul quest. But Arthur Dove and O'Keeffe were sky gazers long before Stieglitz pointed his camera upward in any sustained way.

What's missing in our understanding of Stieglitz is exactly what he spent a lifetime masking: profound susceptibility and visual innocence. As a promoter he acted courageously on behalf of others. As a photographer his best work demonstrates not dominance but a curious need, less often expressed, to surrender to subjects he loved.

The Missing Ten Percent

In the current debate, some insist that Stieglitz's extended portrait of Georgia O'Keeffe, some 350 photographs from 1917 through 1936, was "O'Keeffe's greatest performance"; how Stieglitz depicted her was "as much her doing" as his. Others disagree. She may have provided "the stimulus, and the hints," but in deciding when and how to photograph, he was the one in control.[62] The latter view is constrained by presumptions about how artists traditionally worked with models. In 1889 Stieglitz exercised such control with his mistress, Paula: Sit at the desk.—Pretend to be writing a letter. Traditional opinion doesn't recognize how artist-model relationships changed because of photography, including Stieglitz's own.[63] By 1917, his tactics were more flexible. Besides, he'd fallen madly in love with a riddle.

Instead of regarding Stieglitz's pictures of O'Keeffe as a struggle between two strong, highly divergent individuals, let us reframe the confrontation. Meeting O'Keeffe, the smitten Stieglitz thought he'd found someone with a "'90 percent similarity' to himself."[64] He had his muse and, after a dry period, went to work. At the outset, his protracted examination of her body demonstrates the "heat and excitement"[65] of shameless adoration.

Fig. 9
THE STEERAGE, 1907/print ca. 1915
(pl. 8, cat. 88)

But his obsession, persisting over years, means something else. It is not an example of Stieglitz's notion of portraiture as a day-by-day, body-part-by-body-part record of someone's evolution and growth.[66] Collectively, the extended portrait, dramatic and probing, variable as the weather, magnificently reveals Stieglitz "always photographing himself,"[67] as a failed seeker.

To know O'Keeffe intimately with the camera, he ordered her to stand on a radiator, lie down, etc. Unlike his treatment of Paula, Stieglitz also took O'Keeffe apart photographically—face, hair, hands, neck, breasts, thighs— bone-by-bone, sinew-by-sinew, like an ancient anatomist-alchemist using a lifetime of knowledge to little avail, trying to unlock a Faustian secret as if from a smoldering retort (fig. 10, cat. 114).

Stieglitz tried to isolate an elusive spirit, his new partner who represented the missing ten percent that opposed the ninety percent that was himself. This would never be captured through his or any camera. Not because he and O'Keeffe were vastly different human beings, but because their separate dimensions as artists were irreconcilable.[68]

Fig. 10
GEORGIA O'KEEFFE [Hand], 1918
(cat. 114)

The art reformer initially saw in the school-teacher a prim kid. Sex would eventually change his opinion. But it didn't bring him any closer to her. He'd already seen the kid stripped naked before their physical intimacy, in charcoal drawings he exhibited in 1916. Hanging in 291, O'Keeffe's drawings seemed to qualify as the modernist abstraction Stieglitz understood and admired. From this understanding he launched her career. She became an important member of his stable, by association, another arm of his theory. O'Keeffe didn't object: "It was his game and we all played along or left the game."[69]

Fig. 11
GEORGIA O'KEEFFE, 1930
(cat. 164)

The black-and-white drawings he was excited to show superficially display modernism's geometrical purity and glorious revolt against representation. Stieglitz praised them—"Finally, a woman on paper!"[70] defining O'Keeffe's achievement as an expression of archetypal femininity that had always moved him. Woman as "animal spirituality," described by Mumford.[71] Made by a woman, the drawings were not about being one. They pointed to a place in his own head he'd been loathe to enter, and had hardly acknowledged, much less explored, photographically or otherwise.

O'Keeffe called many of these drawings "Specials." The term signals their obscurity and exceptional meaning for her. It also suggests that the meaning wouldn't easily be penetrated by a reasoning mind. Forms in the "Specials" spew, coil, and curl. They conjure playing fountains or fiddlehead ferns about to be lured into fullness by sunlight. They evoke secretly moving water: ocean waves, rivers, thunderstorms. Bombastic gestures yield to lighter, flame-like tremolos of air or clouds, stirred, shredded, and combed by wind. These forms are not the result of direct observations of particular things. Accumulations of transformative memory, "out of my head," they emerge on paper as if responding to directives from a deep and silent psychic place.[72]

Exulting in their abstraction, for which O'Keeffe, a novice, would be eternally grateful, Stieglitz allowed the drawings a kind of half-life. He may not have fully grasped their origins in the young visionary, nor understood her to be one. Many continue to regard O'Keeffe conventionally, as another of Stieglitz's modernists. She let him define her art as he saw fit, in essence, American. But geographical designations mean little to those whose inspiration transcends locale. O'Keeffe couldn't always explain what she was making. They were "things...I couldn't say in any other way—things that I had no words for."[73]

Artists of this sort, expecting to be visited, often are the last to realize how a line or form arrived on paper or canvas, "not knowing where the ideas came from."[74] In 1919, O'Keeffe would base her painting "From the

Fig. 12
GEORGIA O'KEEFFE, 1918
(cat. 111)

Plains" on "something [she] heard very often—a very special rhythm that would go on for hours and hours...."[75] This is not the same as the "revolt from a dependence on nature" that Kandinsky advised. In 1915 she was rereading his classic tract, though "[s]ome time passed before [she] really began to use the ideas."[76] She'd already been training her soul.[77] Before 1914, her soul was training her—to act as a filter, a conduit of forces she didn't consciously initiate. Defining her process this way hardly diminishes her originality or artistic intelligence. It attempts to explain what Stieglitz may have grasped with difficulty, if at all, and what O'Keeffe was at pains to elucidate.

O'Keeffe spent a lifetime observing. The discipline grounds her art. But the force of her talent, at its best, lies somewhere between that of an attentive viewer who replicates through constant simplification and that of a receiver who has no choice but to surrender to the blazing apparition. If this confused her, the need to seem reasonable to others may explain why she decided to write about how certain drawings came to be made. She recalled that "Special No. 9" (see fig. 14, page 37) was "a drawing of a headache...a very bad headache," which conveys, eloquently, the ineffable, overwhelming impact of her sources.

She didn't stop there—"Well, I had the headache, why not do something with it? So—here it is."[78] Intuitives don't "do something with it." Their images arrive, grab hold, and direct. The self-censoring postscript lacks O'Keeffe's spiritual authenticity. It is as if Stieglitz, from the grave, had spoken through her, redefining her experience as a practical problem and her picture its solution.

In Stieglitz's photographs of O'Keeffe, her body expresses the languid aftermath of lovemaking. Genitals become an archetypal abyss. Hands are schemata of anxiety, predation, lyrical music (fig. 11, cat. 164).[79] Arms raised before her own work are those of an ancient priestess—Totto of Hungary.[80] The range is as rich as the telling is partial. She is a loving, willing model, and then not one at all (pl. 28, cat. 112). "I don't like telling myself to people."[81] This is obvious in the portraits of the 1930s after she had bought the Ford car and was clearly withdrawing, physically and psychologically (see pl. 32). But it occurs throughout the entire portrait group. Understanding the pictures' contradictory beauty is to consider not a mannequin or even a lover as their subject, but a self-possessed seclusive artist of rare originality.

Take the photographer's 1918 snapshot of O'Keeffe working (fig. 12, cat. 111). At Lake George she sits on the ground, facing a bed of late summer flowers. Swathed in a big sweater and long skirt, her figure denotes

complete containment. Beside her is a well-used box of watercolors, glass of water, and a block of watercolor paper. Pressing the shutter, Stieglitz catches her holding a Japanese brush poised over the paper.[82]

He interrupts. Her body language says, Keep Out! Even if they staged the drama—O'Keeffe's left hand seems poised for admiration—the message is clear. Her expression is politely annoyed. The button pusher, curious about, maybe even envious of, someone capable of fifteen-hour work days, whose preoccupations plainly exclude him, breaks her concentration on the shade-loving begonias. Her unavailability in this image is emblematic of the poignant gulf between them in all the others.

Feeling "like flowers sometimes,"[83] O'Keeffe desired space, needed to avoid anyone or anything that would impose and fill it in ways not her own. She atavistically penetrated the insides of things by magnifying flowers through whose centers one feels compelled to travel, into which one gazes hypnotically as if into a well. In *Flatland, A Romance of Many Dimensions*, 1884, English writer Edwin A. Abbott spun a fantasy on the ethics of spatial perception, warning of the superficiality of externals: "What you call Space is really nothing but a great Plane. I am in Space, and look down upon the insides of things of which you only see the outsides."[84] This may as well have been O'Keeffe speaking to her photographer, for Stieglitz relied on externals. Apollonian, he was the sun god, straight shooter, master of billiards, aficionado of racetracks—maps of flatness.

The Japanese brush O'Keeffe holds reflects her adherence to the artistic principles of her teacher, Arthur Wesley Dow, and his "'way' to modernity for everybody."[85] More profoundly, it stands for the artistic and moral philosophies of China and Japan that would increasingly absorb her. Stieglitz knew and promoted these philosophies in *Camera Work* well before meeting O'Keeffe.[86] He didn't take them to heart; Whistler's Orientalism in "Spring Showers" passed like a fad.

O'Keeffe's Eastern thinking endured. Dow's book *Composition* simplified principles and attitudes he'd absorbed from his mentor, Ernest Fenollosa, which led her to read Fenollosa directly. Exactly when is unclear. Fenollosa, returning to America from Japan in 1890, like Stieglitz returning from Europe at the same time, also vowed to reform materialist American culture, but through Eastern standards.[87] Fenollosa was an expert on Noh drama and haiku, a poetic form she loved. Her library contained his *Epochs of Chinese and Japanese Art*, published in 1912.[88]

Early on she also owned *The Book of Tea*, 1906, by Fenollosa's protege, Kakuzo Okakura. Okakura's exquisite text deplored modern commonplaces and modernist artists: "Engrossed in his technique, the modern rarely rises above himself."[89] Shades of Stieglitz. In the chapter devoted to flowers, Okakura attributed to them magical powers: one is obliged "to gladden" flowers "with soft music" at the tea ceremony to acknowledge their majesty with a profound bow.

> Where better than in a flower, sweet in its unconsciousness, fragrant because of its silence, can we image the unfolding of a virgin soul?...[P]rimeval man offering the first garland to his maiden...entered the realm of art when he perceived the subtle use of the useless.

In this O'Keeffe found the sweet unconsciousness and silence of her own sensibility reaffirmed. Flowers: "We dare not die without them."[90] She had *The Book of Tea* read to her until her last breath.

The Continuation of a Long Fight

Showing Walker Evans a photograph of tree bark, Stieglitz praised himself, exclaiming, "It was YEARS before I DARED to do it."[91] More of Stieglitz's insecurity, thought the younger man. Once again the reformer had delayed what mattered.

It was years before he dared to concentrate on clouds. He called the first pictures of 1922 *Music—A Sequence of Ten Cloud Photographs* (see fig. 6, page 15, pl. 24, cat. 123). This wasn't the piano music he'd failed to pursue; it transcended the drawing room. In his delirium he imagined Jewish composer Ernest Bloch seeing the clouds and crying, "Music! music! Man, why that is music!" He would be inspired to write a "cloud" symphony. Stieglitz declared the dream had come true "*verbatim.*"[92]

The reverie recalls the stallions recorded only in his memory. In subsequent cloud pictures, called "Equivalents," Stieglitz found an equally mythical vision of the winged steed Pegasus, whose nervous hoof caused the fountain

of the Muses to gush forth. Slices from a heavenly bolt of cloth, the "Equivalents" ebb and flow, opaque to evanescent (see fig. 13, cat. 133). They brood and explode in a mercurial timetable like the tides. Deliberately disorienting, they refer to no horizon. Gorgeous unfurlings of psychic places buried for too long, the clouds are the closest Stieglitz ever came to visualizing his dream life. Intuitively received rather than captured, they share qualities of O'Keeffe's "Specials" (see fig. 14). No wonder he raved about them.

The "Equivalents" are among his best photographs. He had no program. Yet, as Dow taught, he filled "space in a beautiful way."[93] As the eleventh-century Chinese painter and theorist Kakki (Kuo Hsi) observed about painting clouds, one had to respond to their myriad changes—in spring, mild and calm, in summer, thick and brooding (melancholy), in autumn, rare and thin, in winter, dark and gray. Stieglitz ignored seasons, understanding the ancient wisdom that "if one does not try to carve out very minute detail," but depicts "only the great total aspect of the thing, the forms and proportions of the clouds will live."[94]

He'd grasped the powerful variability of light. Earlier he'd marshaled it through a window blind ("Paula, Berlin," 1889) or used it conventionally to model objects. Now he filled his frames with other Lake George subjects, transposing what the clouds taught to studies of trees, brush, fields of grass (pl. 27, cat. 185). Farm buildings at Lake George became "Sphinx & pyramids" with "unbelievable dignity" (pl. 18, cat. 192).[95] The moon, everything light-flooded, acquired a force of spirit that previously had eluded him. Later Lake George landscapes and close-ups of the aging poplars planted by his father ceased to denote their subjects. Variants of the clouds, they suggest that Stieglitz, like a Zen master, hadn't improved; he'd achieved on paper an inner vision.

He photographed clouds "to find out what [he'd] learned in 40 years about photography."[96] More accurately, clouds were a means of exploring what he'd learned by exhibiting and purchasing, for his own collection, the vitalistic paintings of an artist like Arthur Dove. "Something in Brown, Carmine, and Blue," 1927 (fig. 15), by Dove, belonged to Stieglitz.[97] If the rivulet pattern of branches filling the frame in Stieglitz's "Poplars, Lake George," 1932 (fig. 16, pl. 26, cat. 181), seems inconceivable before the "Equivalents," it is equally so without the photographer's having pondered Dove's penetration into something brown, the woody, secret sharings of a tree's interior.

Then there was O'Keeffe. No one denies that her presence changed him utterly. Even the servants declared the influence. According to Margaret Prosser (pl. 34, cat. 183), the Stieglitz family's cook,

Fig. 15
Arthur Dove
SOMETHING IN BROWN, CARMINE, AND BLUE,
1927
Oil on metal
Courtesy Fisk University Galleries, Nashville, Tennessee

> Mr. Alfred never would have been the photographer he later was if he hadn't got with Georgia.
> I saw his early photographs. I saw his late photographs, the negatives would hang up in my kitchen
> to dry. I saw them all, and I heard him talk about them all, and what they meant. He did wonderful
> street scenes, portraits, railroad tracks and all that before Georgia came. But after Georgia came,
> he made the clouds, the moon, he even made lightning. He never photographed things like that before.[98]

Writers on Stieglitz's photography seem to eschew the influential roles of painters he knew well. Following his lead they maintain the modernist's insistence that photography had to be about itself. Future accounts of Stieglitz's photography must resist this partiality and incorporate the immense and growing literature about O'Keeffe, new treatments of Dove and others in the Stieglitz circle. Why hide it? O'Keeffe was as open as she could be:

Fig. 16
POPLARS, LAKE GEORGE, 1932
(pl. 26, cat. 181)

His prints of this year are all 4 by five inches all of the sky. They are very wonderful—way off the earth but four or five that are of barns and snow....His is the continuation of a long fight——Mine—...He has done with the sky something similar to what I had done with color before—as he says—proving my case—He has done consciously something that I did mostly unconsciously———and it is amazing to see how he has done it out of the sky with the camera—.[99]

Fig. 17
THE HAND OF MAN, 1902/print ca. 1924–1934
(pl. 6, cat. 70)

Realism was repellent to her. Nothing was less real. Photographers had no traditions to work from, she said. They would have to invent this tradition by showing what they themselves could do. Stieglitz proved her case, doing consciously with the camera (fig. 17, pl. 6, cat. 70) what she had done mostly unconsciously with a brush (fig. 18). Escaping the rigors of his little box, he managed to amaze her. And he was grateful: "For Georgia/ without whose being I/ would not be what I am—Alfred," he wrote.[100]

Yet older ideas endured. Woman was animal spirituality, a formidable adversary. Stieglitz would confound the archetype with photography itself. Aged seventy-four and clearly over-written about, he proposed a future biography—reduced to an epigram:

> If you can imagine photography in the guise of a woman & you asked her what she thought of Stieglitz, she'd say: "He always treated me as a gentleman."[101]

Another of his saws, perhaps, but change for him was difficult. Liberated through clouds, the man whose "intensity keyed up to 999 degrees of will"[102] maintained uncharacteristic reserve, even humility. In his own estimation, he was ever the nineteenth-century gallant, photography's jealous courtier.

Fig. 18
Georgia O'Keeffe
TRAIN AT NIGHT IN THE DESERT, 1916
Watercolor and graphite on paper
Amarillo Museum of Art purchase
Courtesy The Georgia O'Keeffe Foundation

Notes

1. The event was important enough for Dorothy Norman to record it in *Alfred Stieglitz, Introduction to an American Seer* (New York: Duell, Sloan and Pearce, 1960), p. 23. "I felt his words were quite well worth preserving as were his photographs....I would attempt to share what I heard him say, and what I felt he signified," title page.

2. Sherwood Anderson, *A Storyteller's Story, A Critical Text*, edited with an introduction by Ray Lewis White (Cleveland: The Press of Case Western Reserve University, 1968), p. 313. Anderson, also a regular racetrack visitor, writes: "At the sight of such a horse as we were now watching, as the saddle was put on, something strange happened to him. A soft light came into his eyes....I had seen such a light in the eyes of Alfred Stieglitz in the presence of a painting," p. 314.

3. Georgia O'Keeffe, "Stieglitz: His Pictures Collected Him," *The New York Times Sunday Magazine* (December 11, 1949), p. 24.

4. Lewis Mumford, "The Metropolitan Milieu," *America and Alfred Stieglitz, A Collective Portrait*, ed. Waldo Frank, Lewis Mumford, Dorothy Norman, et al. (Millerton: Aperture, Inc., 1979), p. 34.

5. *Ibid.*, p. 35.

6. Norman, *Alfred Stieglitz, Introduction to an American Seer*, p. 23.

7. Mumford, "The Metropolitan Milieu," p. 35.

8. John Szarkowski, in *In Focus: Alfred Stieglitz, Photographs from The J. Paul Getty Museum* (Malibu: The J. Paul Getty Museum, 1995), p. 123. The text of this book derives from a discussion of Stieglitz's life and art at the Grolier Club in New York City, October 5, 1993. Participants included Emmet Gowin, Sarah Greenough, Weston Naef, John Szarkowski, and moderator Charles Hagen.

9. Mumford, "The Metropolitan Milieu," p. 35.

10. Stieglitz's entire body of work is known well only by a few curators and scholars. They may be aware of some racing pictures, but the images are not known to this writer.

11. Norman, *Alfred Stieglitz, Introduction to an American Seer*, p. 9.

12. Dorothy Norman, *Alfred Stieglitz: An American Seer* (New York: Random House, 1973), p. 36.

13. Norman, *Alfred Stieglitz, Introduction to an American Seer*, p. 30.

14. The pose of this horse is fleshed out in "A Snapshot," 1911, made in Paris, where a horse hitched to a wagon occupies the middle distance. Even in the city of stallions, this animal, its bridle held by a groom or driver, seems weighed down by the care and weariness that Stieglitz sought in New York geldings. See Norman, *Alfred Stieglitz: An American Seer*, plate XXV.

15. Stieglitz, reported by Norman in *Alfred Stieglitz, Introduction to an American Seer*, page unnumbered (39).

16. John Szarkowski, *Alfred Stieglitz at Lake George* (New York: The Museum of Modern Art, 1993), p. 9.

17. To which one ventures to add, great ones. *Ibid.* Szarkowski's information, published in 1993, doesn't appear to take into account Sarah Greenough's statement later that year that the National Gallery possesses 1,600 of his photographs. Add to this some twenty to thirty, known only through reproductions, and another thirty to fifty from the rest of his career that "we don't have," Greenough reckons a total of about 1,700 images. The number seems substantial, but for almost sixty years of work, roughly calculated, it means only about 29 images a year. Szarkowski's point stands. The list is short. Greenough seems to concur: "To a great extent, we know Stieglitz primarily through the images that he selected later in his life." Szarkowski, *In Focus: Alfred Stieglitz, Photographs from the J. Paul Getty Museum,* p. 104.

18. Stieglitz is discussing the photographs of Paul Strand in *Camera Work*, Number 49/50 (1917). See *Camera Work: A Critical Anthology*, edited and with an introduction by Jonathan Green (Millerton: Aperture, Inc., 1973), p. 329.

19. O'Keeffe, "Stieglitz: His Pictures Collected Him," p. 25.

20. In Hartmann's letter to Stieglitz September 2, 1904, quoted in *The Valiant Knights of Daguerre, Selected Critical Essays on Photography and Profiles of Photographic Pioneers by Sadakichi Hartmann*, ed. Harry W. Lawton and George Knox, with the collaboration of Wistaria Hartmann Linton, et al. (Berkeley: University of California Press, 1978), 18 n, p. 316.

21. Critic Edmund Wilson, quoted in James R. Mellow, *Walker Evans* (New York: Basic Books, 1999), p. 89.

22. Norman, *Alfred Stieglitz, Introduction to an American Seer*, p. 3.

23. Anderson, *A Storyteller's Story*, page unnumbered.

24. Written to Anita Pollitzer, October 11, 1915, in Jack Cowart, Juan Hamilton, and Sarah Greenough, *Georgia O'Keeffe, Art and Letters*, letters selected and annotated by Sarah Greenough (Washington, D.C.: National Gallery of Art, in association with New York: New York Graphic Society Books, and Boston: Little, Brown and Company, 1987), p. 144.

25. Alfred Stieglitz, *Georgia O'Keeffe, A Portrait by Alfred Stieglitz*, with an introduction by Georgia O'Keeffe (New York: The Metropolitan Museum of Art, 1978), reprinted with additions in 1997, pages unnumbered.

26. Walker Evans writing to Hanns Skolle, March 17, 1929, quoted in Mellow, *Walker Evans*, p. 88.

27. Waldo Frank, "The New World in Alfred Stieglitz," in *America and Alfred Stieglitz, A Collective Portrait*, p. 109.

28. Sue Davidson Lowe, *Stieglitz, A Memoir/Biography* (New York: Farrar Straus Giroux, 1983), p. 66.

29. *Ibid.*, p. 137.

30. The slogan recurs throughout Stieglitz's remarks and in the many writings that attempt to explain him, e.g. Mumford, "The Metropolitan Milieu," p. 34.

31. Georgia O'Keeffe writing to Sherwood Anderson, quoted in Benita Eisler, *O'Keeffe and Stieglitz, An American Romance* (New York: Doubleday, 1991), p. 288.

32. See F. Richard Thomas, "Hart Crane, Alfred Stieglitz, and Camera Photography," *The Centennial Review*, vol. 21, no. 3 (Summer 1977), pp. 294–309. Crane came to An American Place to read to Stieglitz from "The Bridge" before it was published and wrote that he felt Stieglitz "entering very strongly into certain developments" of the poem. Norman, *Alfred Stieglitz: An American Seer*, p. 195.

33. She explains in *Georgia O'Keeffe, A Portrait by Alfred Stieglitz*, page unnumbered.

34. William Murrell Fisher, "The Georgia O'Keeffe Drawings and Paintings at '291'," *Camera Work*, Number 49/50 (1917). See *Camera Work: A Critical Anthology*, p. 228.

35. Stieglitz, *Georgia O'Keeffe, A Portrait by Alfred Stieglitz*, page unnumbered.

36. Sarah Greenough's well-annotated selection, from 1892 to 1942, appears in Sarah Greenough and Juan Hamilton, *Alfred Stieglitz, Photographs and Writings* (Washington, D.C.: National Gallery of Art, 1999), pp. 178–238.

37. In *Camera Work*, Number 47 (1914–1915). See *Camera Work: A Critical Anthology*, p. 295.

38. Eisler, *O'Keeffe and Stieglitz, An American Romance*, p. 367. Eisler is quoting from Calvin Tompkins's unpublished "Notes from an Interview with Georgia O'Keeffe," listed as such in her bibliography.

39. *Ibid.*, p. 229. Eisler is quoting from Frank's *Our America* (New York: Boni & Liveright, 1919), p. 186.

40. *Ibid.*, p. 229. Letter from Stieglitz to Waldo Frank, April 3, 1925.

41. Weston Naef in *In Focus: Alfred Stieglitz...*, p. 8.

42. *Ibid.*, book jacket text.

43. Eisler's well-documented book at times suffers from this tone.

44. *Georgia O'Keeffe, the poetry of things*, exhibition catalogue, by Elizabeth Hutton Turner, with an essay by Marjorie P. Balge-Crozier (Washington, D.C.: The Phillips Collection, and New Haven: The Yale University Press, in association with the Dallas Museum of Art, 1999), p. vii.

45. To which process Barbara Buhler Lynes's *Georgia O'Keeffe Catalogue Raisonne* (New Haven: Yale University Press, in association with Washington, D.C. and Abiquiu, New Mexico: The Georgia O'Keeffe Foundation, 1999), 2 vols., is of incalculable value in presenting, for the first time, all of the work deemed to be by her, in color and in chronological order.

46. Stieglitz writing to Sadakichi Hartmann, November 22, 1930, quoted in *The Valiant Knights of Daguerre*, p. 28.

47. Szarkowski, *Alfred Stieglitz at Lake George*, p. 12, quotes art collector John Quinn, writing to painter Augustus John.

48. Mellow, *Walker Evans*, p. 91.

49. After 1946 O'Keeffe, as her husband's executrix, spent many years away from her own painting, devoting herself to placing the enormous number of pictures Stieglitz had collected, as well as his own photographs, in important museums that would protect them and honor his memory. She regarded her task less as a personal sacrifice than an important final tribute to Stieglitz's accomplishment by meeting his standards for how *all* works of art should be treated. The preceding essay in this catalogue more fully explains O'Keeffe's task and reasoning.

50. John Szarkowski, *Photography until Now* (New York: The Museum of Modern Art, 1989), is distinguished in recognizing the vitality of this pluralism. Throughout, illustrations of important works by recognized photographers join equally, if not more, arresting and beautiful images by the obscure and unknown. George Eastman House, since its founding in 1949, set the precedent of commitment to the same principles of photography's hybrid vigor. The most recent of its many publications celebrating this mixture, *Photography from 1839 to Today*, edited by Therese Mulligan and David Wooters (Köln: Taschen Verlag, 1999), devotes nearly 800 pages to illustrating and discussing photography as an art, but more importantly, as a phenomenon of global visual culture.

51. Horace Gregory, *The World of James McNeill Whistler* (London: Hutchinson & Co., 1961), pp. 17–18. In 1878, Whistler sued critic John Ruskin for saying in print that the painter had thrown a pot of paint in the public's face. The court proceedings allowed Whistler a chance to define art on his own terms, after which the court awarded him a mere farthing in damages.

52. Stieglitz writing to J. Dudley Johnson, April 3, 1925, in Greenough and Hamilton, *Alfred Stieglitz, Photographs and Writings*, p. 208.

53. "Stieglitz has to do everything in his mind so many times before he does it in reality that it keeps the process of anything...going on for a long time....—He has to go over and over...again and again—trying to understand what it is that he is and why—in relation to the world—and what the world is and where it is all going to and what it is all about—and the poor little thing is looking for a place in it—and doesn't see any place where he thinks he fits." O'Keeffe to Sherwood Anderson, June 11, 1924, *Georgia O'Keeffe, Art and Letters*, p. 177.

54. I base these opinions on many conversations I have had for some thirty years with European colleagues. I was surprised to learn that many French find America's infatuation with Eugène Atget equally perplexing since they continue to regard him as a mere documenter. Nor do they like the documentary or documentary-style photographs of Americans Lewis Hine or Walker Evans, finding the subject matter depressing and its expression either boring or emotionally bankrupt.

55. Joel Smith, in *Edward Steichen: The Early Years* (Princeton: Princeton University Press in association with New York: The Metropolitan Museum of Art, 1999), p. 25, demonstrates this by comparing Stieglitz's "Flat-Iron" of 1902, printed ca. 1913, figure 16, to the same subject by Steichen in plates 17–20. Focusing on Stieglitz's early collaborator, Smith's title essay includes trenchant commentary on Stieglitz as well. As a distinguished and balanced critical treatment of a photographer from this period, Smith's is a model of its kind in boldly expressing, with intelligence and levity, qualities of character that actively determined the course and varied quality of Steichen's work. Hopefully, one day Stieglitz will enjoy similarly delightful and sustained incisive attention.

56. P. H. Emerson, "Hints on Art," in *Naturalistic Photography for Students of the Art* (New York: E. & F. Spon, 1890), p. 255. Stieglitz's writings and repeated declarations of what constituted an art of photography often echo Emerson's thorough treatment here.

57. Naef, *In Focus: Alfred Stieglitz...*, p. 12.

58. Paul Rosenfeld, "The Boy in the Dark Room," in *America and Alfred Stieglitz, A Collective Portrait*, p. 46.

59. Szarkowski, *Alfred Stieglitz at Lake George*, p. 14.

60. Sarah Greenough and Emmet Gowin in *In Focus: Alfred Stieglitz...*, p. 122.

61. They were Mexican caricaturist Marius De Zayas and collector Paul Haviland. *Ibid.*, p. 112.

62. *Ibid.*, pp. 125–128. Stieglitz's "control" in these pictures is Sarah Greenough's opinion. Weston Naef agrees.

63. A phenomenon explored by Arthur Ollman, *The Model Wife, Photographs by Baron Adolph de Meyer, Alfred Stieglitz, Edward Weston, Harry Callahan, Emmet Gowin, Lee Friedlander, Masahisa Fukase, Seiichi Furuya, and Nicholas Nixon* (Boston: A Bulfinch Press Book/Little, Brown and Company, published in association with San Diego: The Museum of Photographic Arts, 1999).

64. *Ibid.*, p. 56. No source cited.

65. O'Keeffe in *Georgia O'Keeffe, A Portrait by Alfred Stieglitz*, page unnumbered.

66. *Ibid.*, page unnumbered. O'Keeffe mentions as a prototype the abandoned project to record his daughter Kitty in a "photographic diary." But this seems like adherence to what was already thought. It is not certain whether she thought he was recording her in that manner.

67. *Ibid.* And many close readers of Stieglitz seem to agree. See *In Focus: Alfred Stieglitz...*, p. 128.

68. See *Georgia O'Keeffe & Alfred Stieglitz, Two Lives, A Conversation in Paintings and Photographs*, essays by Belinda Rathbone, Roger Shattuck, Elizabeth Hutton Turner, ed. Alexandra Arrowsmith and Thomas West (New York: Callaway Editions, 1992). This intriguing exhibition and catalogue sought to establish thematic parallels between the artists by placing their work side by side. In a comparison that declares the richness of their irreconcilability, "The Hand of Man," 1902, is joined to O'Keeffe's watercolor "Night Train in the Desert," 1916. Using Stieglitz's photograph as a point of departure, she reduced the oncoming train to a pin point and let its light-pool of billowing smoke render a railroad subject into a hallucination.

69. O'Keeffe, "Stieglitz: His Pictures Collected Him," p. 24.

70. The expression was important enough for Pollitzer to repeat it as the title of her book, *A Woman on Paper: Georgia O'Keeffe, The Letters & Memoir of a Legendary Friendship* (New York: Simon and Schuster, 1988), see p. 48.

71. Mumford, "The Metropolitan Milieu," p. 34.

72. All catalogued and illustrated in Lynes, *Georgia O'Keeffe, Catalogue Raisonne*, vol. I, nos. 45–56, 59–61. *Second, Out of My Head* is no. 56.

73. From O'Keeffe's exhibition statement of 1923, *Georgia O'Keeffe* (New York: The Viking Press, 1976), pages unnumbered (comment near plate 13). The excellent scholars reinvestigating the painter's sources may object to my apparent simplism here. Barbara Hutton Turner's "The Real Meaning of Things," in *Georgia O'Keeffe: the poetry of things*, pp. 1–22, argues superbly for the artist's many influences, especially Asian ones at the outset of her career. Art history always suffers from the problem of seeming to grant intentionality to what an artist will usually protest was merely felt. The discipline rarely ventures into the mystery of the creative process. Aiming to demystify, it has to falsify what to an artist remains ineffable. This doesn't invalidate either the artist's point of view or the method of the explainer. It merely cautions. In this essay on Stieglitz my aim is to represent O'Keeffe as she viewed herself, especially as Stieglitz's model. It questions Stieglitz's confidence that in photographing her so often he necessarily understood her.

74. *Georgia O'Keeffe, Some Memories of Drawings*, ed. Doris Bry (Albuquerque: The University of New Mexico Press, 1988), text for plate 4.

75. Lynes, entry for *Series I—From the Plains*, vol. I, cat. no. 288, p. 155.

76. Quoted in *The Spiritual in Art: Abstract Painting 1890–1985*, organized by Maurice Tuchman, in collaboration with Carel Blotkamp, Flip Bool, John E. Bowlt, et al. (Los Angeles: Los Angeles County Museum of Art, 1986), p. 412, a catalogue wherein O'Keeffe figures notably. As one of the first to explore abstraction in depth, and the myriad spiritual underpinnings that engendered it, this exhibition and its publication seek to link O'Keeffe's art and the art of many others to a logically determinable series of influences, a comprehensible reasonability eligible for traditional art historical treatment. The writers link to symbolism O'Keeffe's distillations of reality that merged abstraction with subjective meaning. They were probably not in response to the French movement, Emersonian Transcendentalism, William Blake, or any other influence at the outset, at least. She learned to think of what she was doing in broader terms as she evolved, finding in Arthur Dove, for example, a soul mate. He was influenced by vitalism, theosophy, "astrology, occult numerology, and the cabala," p. 43. O'Keeffe probably was not. Dove never exhibited his *Abstractions*. The two artists were linked by the fear of being misunderstood, as well as a secret desire to remain obscure. As O'Keeffe wrote to Pollitzer in October 1915: "I always have a curious sort of feeling about some of my things—I hate to show them—I am perfectly inconsistent about it—I am afraid people won't understand and—I hope they won't—am afraid they will." Quoted in Eisler, *O'Keeffe and Stieglitz, An American Romance*, p. 3.

77. As Wassily Kandinsky advised in *Concerning the Spiritual in Art*, translated with an introduction by M. T. H. Sadler (New York: Dover Publications, Inc., 1977), pp. 46–47.

78. O'Keeffe, *Some Memories of Drawings*, text accompanying plate 5. Lynes, vol. I, cat. no. 54, quotes the same text but excludes the final sentence.

79. Written three years earlier, Sherwood Anderson's stories in *Winesburg, Ohio*, 1919, use hands prominently to convey certain portraits, e.g. those of Dr. Reefy in "Paper Pills." Stieglitz and O'Keeffe read the book to one another.

80. Stieglitz designated O'Keeffe, a Wisconsin farm girl, as a quintessential American. Her middle name, Totto, honored George Totto, her maternal grandfather, a count from Budapest. Laurie Lisle, *Portrait of an Artist, A Biography of Georgia O'Keeffe* (New York: Washington Square Press, 1980), pp. 3–5. This helps explain her distinctive features. Neither Celtic, Anglo-Saxon, nor conventionally American, they carry the severity of Eastern Europe, which contributes to her unfamiliar, harsh aspect, even when young, in pictures where she poses in a Kafkaesque hat, in street clothes before

81. To Sherwood Anderson, August 1, 1923?, *Georgia O'Keeffe, Art and Letters*, p. 172.

82. Another lesser-known image by Stieglitz, obviously from the same moment, shows O'Keeffe intently painting. In the National Gallery of Art, Washington, D.C., Alfred Stieglitz Collection, it is reproduced on the back of the jacket of Lynes, vol. I.

83. Writing to Anita Pollitzer, October 1915, Pollitzer, *A Woman on Paper*, p. 28.

84. A. Square (Edwin Abbott), *Flatland, A Romance of Many Dimensions*, illustrations by the author, introduction by Alan Lightman (New York: Penguin Books, 1998), p. 91. Space permits only a hint here of what further application of this spatial romance to Stieglitz and O'Keeffe as artists would more emphatically reveal of their differences.

85. See Joseph Masheck, "Dow's 'Way' to Modernity for Everybody," introduction to Arthur Wesley Dow, *Composition, A Series of Exercises in Art Structure for the Use of Students and Teachers* (Berkeley: University of California Press, 1997), p. 1.

86. On the "success" of the Japanese in fully recognizing "the Spiritual," see Charles H. Caffin, "Of Verities and Illusions," *Camera Work*, number 12 (October 1905), *Camera Work: A Critical Anthology*, pp. 55–60. O'Keeffe discovered Caffin independently. See Ruth E. Fine, Elizabeth Glassman, Juan Hamilton, *The Book Room: Georgia O'Keeffe's Library in Abiquiu*, catalogue entries by Sarah L. Burt (New York: The Grolier Club, Abiquiu: The Georgia O'Keeffe Foundation, 1997), pp. 22–23.

87. In the new, rigorous analysis currently being applied to O'Keeffe's work, Elizabeth Hutton Turner, "The Real Meaning of Things," *Georgia O'Keeffe: the poetry of things*, uses this portrait as a point of departure to explore the many possible Eastern influences on the painter. She does not address Stieglitz's role except as a recorder. Insisting on O'Keeffe's basic formalism, nonetheless, she cites Barbara Rose as one of the first to posit Fenollosa as the "missing link" for the painter's "interest in transcendentalist thought and Far Eastern art." 4 n, p. 141.

88. Fine, et al., *The Book Room*, p. 29.

89. Kakuzo Okakura, *The Book of Tea*, foreword and afterword by Soshitsu Sen XV (Tokyo: Kodansha International Ltd., 1989), p. 99. The book was written in English.

90. *Ibid.*, "Flowers," pp. 109–124.

91. Mellow, *Walker Evans*, p. 89.

92. Alfred Stieglitz, "How I Came to Photograph Clouds," *Amateur Photographer and Photography*, September 19, 1923. See *Alfred Stieglitz: Photographs and Writings*, pp. 206–208.

93. Turner, "The Real Meaning of Things," p. 1.

94. Ernest F. Fenollosa quoting "extracts supposed to be in the very words of Kakki," in "Idealistic Art in China," *Epochs of Chinese and Japanese Art* (New York: Dover Publications, Inc., 1963), vol. II, pp. 14–15.

95. Letter to Sherwood Anderson, November 28, 1923, in *Alfred Stieglitz: Photographs and Writings*, p. 209.

96. Stieglitz, "How I Came to Photograph Clouds," p. 207.

97. Debra Bricker Balken with William C. Agee and Elizabeth Hutton Turner, *Arthur Dove: A Retrospective* (Andover: The Addison Gallery of American Art, Washington, D. C.: The Phillips Collection, Cambridge: The MIT Press, 1997), plate 42.

98. From Pollitzer's interview with Prosser, *Woman on Paper*, pp. 169, 172.

99. Letter to Sherwood Anderson, February 11, 1924, *Georgia O'Keeffe, Art and Letters*, p. 176.

100. Inscribed on a copy of *America and Alfred Stieglitz: A Collective Portrait* in O'Keeffe's Abiquiu library, *The Book Room*, p. 32.

101. Letter to Edward Weston, September 3, 1938, *Alfred Stieglitz: Photographs and Writings*, p. 219. The syntax is confusing. Stieglitz obviously doesn't mean that he treated her as if she were a gentleman, rather that he treated her as a gentleman would a lady.

102. Alfred Stieglitz to Arthur Dove, August 7, 1922. Cited in Sarah Greenough's quote from "The American Earth: Alfred Stieglitz's Photographs of Apples," *Art Journal*, Spring 1981, p. 51.

paintings of her authorship, and when older, to her androgyny.

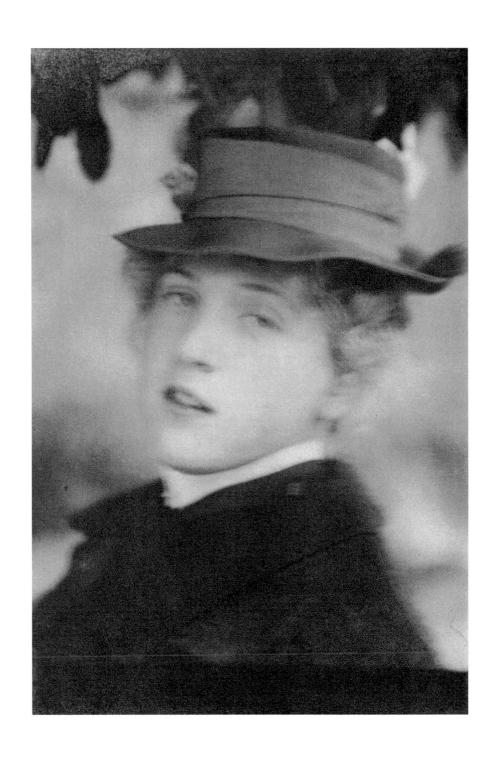

Plate 1

PORTRAIT—S.R., 1904.

(cat. 73)

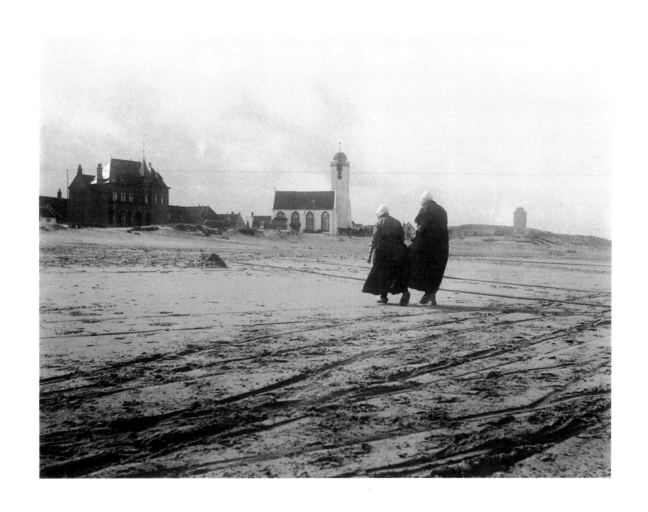

Plate 2

SCURRYING HOME, 1894. Print ca. 1924–1934.

(cat. 51)

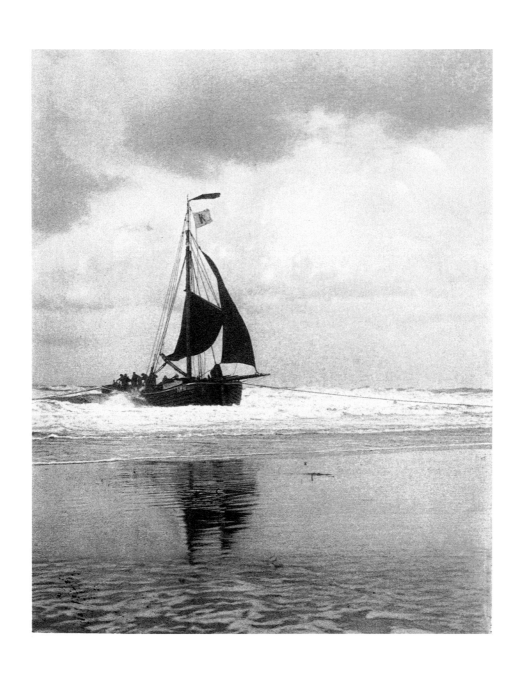

Plate 3

THE INCOMING BOAT, ca. 1894.

(cat. 28)

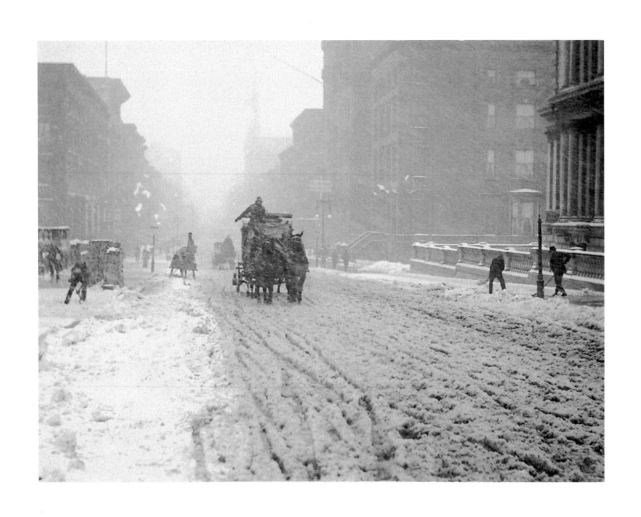

Plate 4

WINTER—FIFTH AVENUE, 1893. Print ca. 1924–1934.

(cat. 20)

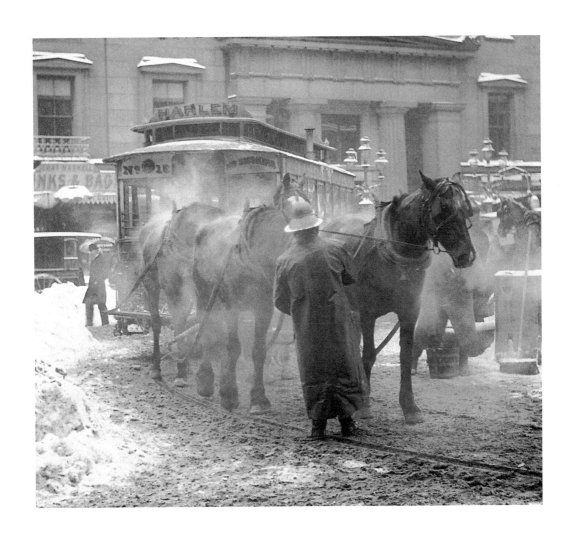

THE TERMINAL (NEW YORK), 1893.

(cat. 16)

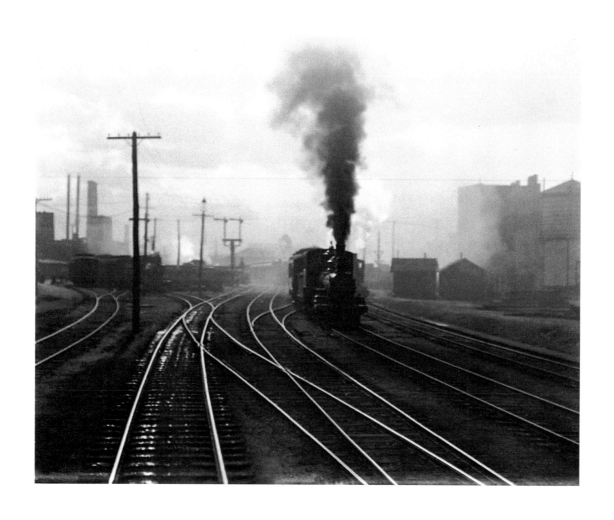

Plate 6

THE HAND OF MAN, 1902. Print ca. 1924–1934.

(cat. 70)

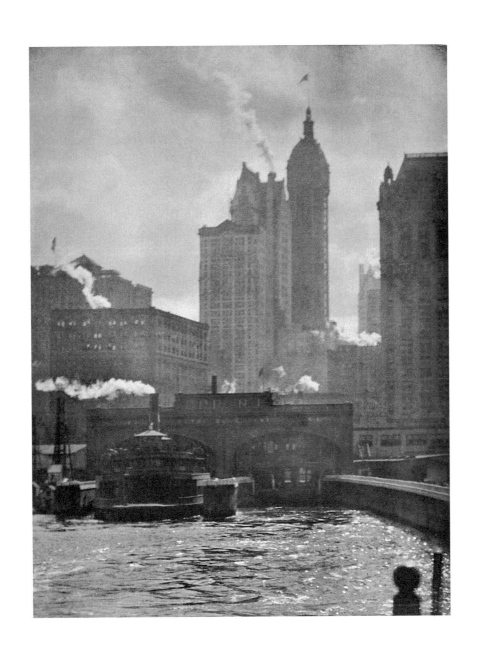

Plate 7

THE CITY OF AMBITION, 1910. Printed 1911.

(cat. 93)

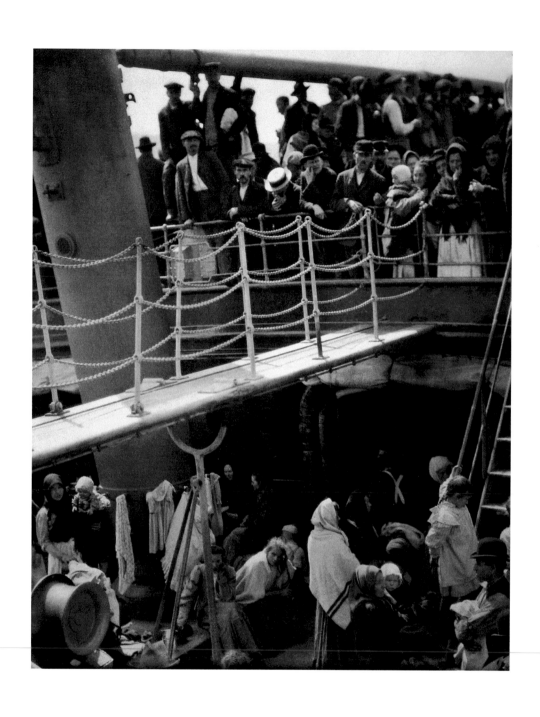

Plate 8

THE STEERAGE, 1907. Print ca. 1915.

(cat. 88)

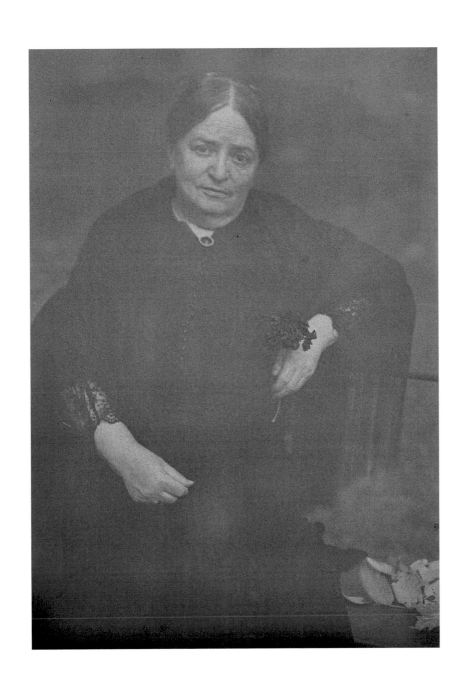

Plate 9

[Hedwig Werner Stieglitz with red flower], ca. 1907.

(cat. 79)

Plate 10

[Katherine Stieglitz and Elizabeth Stieglitz], 1907.

(cat. 83)

Plate 11

[Katherine Stieglitz with tennis racquet], ca. 1915.

(cat. 107)

Plate 12

[Frank Eugene with stein of beer], 1907.

(cat. 82)

Plate 13

[Portrait of Marie Rapp (Boursault)], 1915.

(cat. 108)

Plate 14

DOROTHY TRUE, 1919.

(cat. 116)

Plate 15

DOROTHY TRUE, 1919.

(cat. 115)

Plate 16

ELLEN KOENIGER, LAKE GEORGE, 1916.

(cat. 110)

Plate 17

PORTRAIT OF R., 1923.

(cat. 127)

Plate 18

LAKE GEORGE, 1936.

(cat. 192)

Plate 19

EQUIVALENT, 1923.

(cat. 132)

Plate 20

EQUIVALENT, 1924–1925.

(cat. 138)

Plate 21

EQUIVALENT, 1927.

(cat. 153)

Plate 22

EQUIVALENT, 1930.

(cat. 167)

Plate 23

EQUIVALENT, 1931.

(cat. 171)

Plate 24

CLOUDS, MUSIC NO. 1, LAKE GEORGE, 1922.

(cat. 123)

Plate 25

GRAPE LEAVES AND HOUSE, LAKE GEORGE, 1934.

(cat. 187)

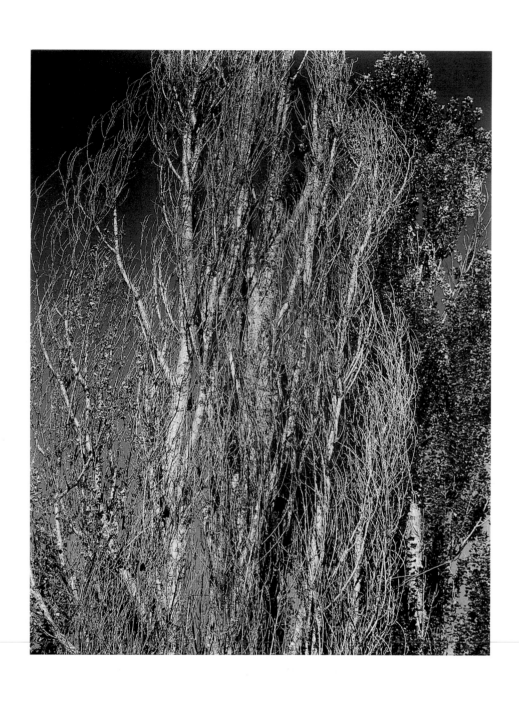

Plate 26

POPLARS, LAKE GEORGE, 1932.

(cat. 181)

Plate 27

HEDGE AND GRASSES, LAKE GEORGE, 1933.

(cat. 185)

Plate 28

GEORGIA O'KEEFFE, 1918.

(cat. 112)

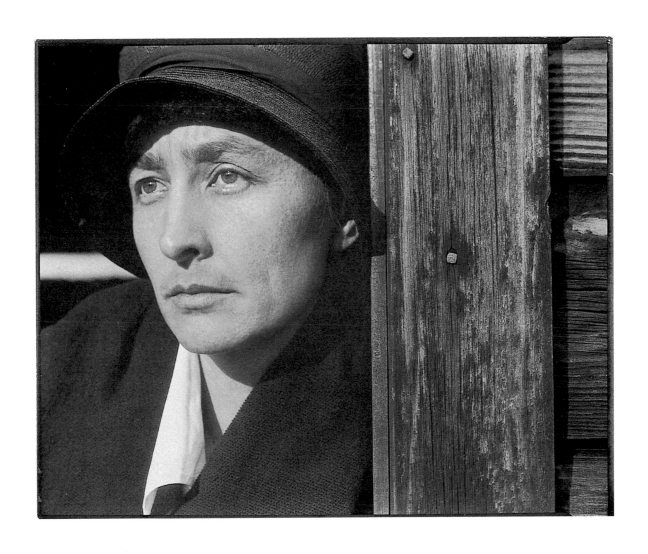

Plate 29

GEORGIA O'KEEFFE, 1922.

(cat. 124)

Plate 30

GEORGIA O'KEEFFE, 1920.

(cat. 119)

Plate 31

GEORGIA O'KEEFFE, 1930.

(cat. 163)

Plate 32

GEORGIA O'KEEFFE, 1933.

(cat. 184)

Plate 33

[Ford V-8], 1935.

(cat. 188)

Plate 34

[Margaret Prosser's clasped hands in lap], 1933.

(cat. 183)

Plate 35

DOROTHY NORMAN, 1931.

(cat. 174)

Plate 36

FROM AN AMERICAN PLACE, LOOKING NORTH, 1931.

(cat. 177)

Plate 37

NEW YORK SERIES, SPRING, 1935.

(cat. 191)

Plate 38

NEW YORK SERIES, 1935.

(cat. 190)

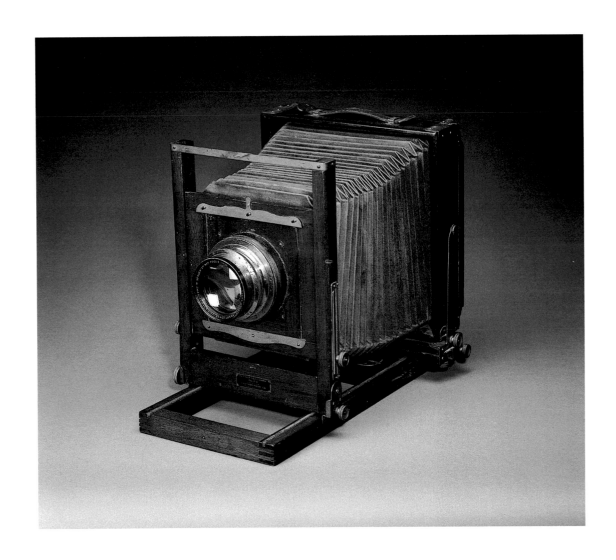

EASTMAN NO. 2D VIEW CAMERA, ca. 1921.

(cat. 196)

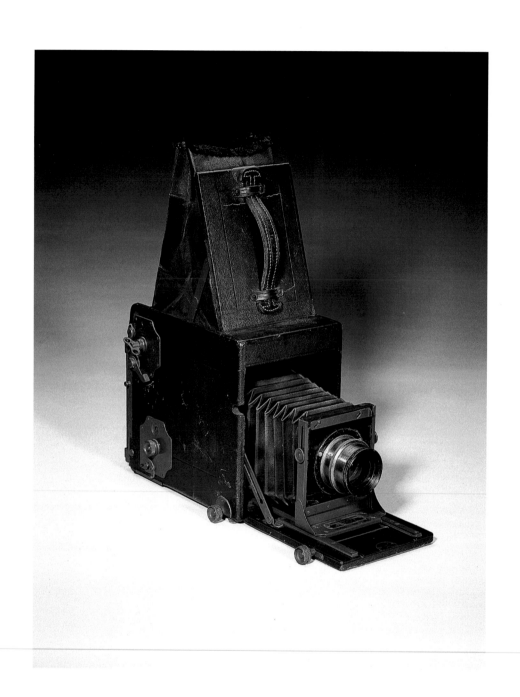

Plate 40

RB AUTO GRAFLEX CAMERA, ca. 1910.

(cat. 195)

This catalogue represents the complete holdings of the Alfred Stieglitz collection preserved in the photography and technology collections at George Eastman House. Unless otherwise noted, all holdings were acquired from Georgia O'Keeffe.

All photographs published herein are by Alfred Stieglitz (American, 1864–1946), with exceptions noted. They are presented in chronological order. Measurements of the actual images are given in centimeters, height preceding width. Catalogue entries for cameras and related objects owned by Stieglitz are arranged chronologically, first citing the product's name, then manufacturer.

Manuscript materials relating to Alfred Stieglitz, Georgia O'Keeffe, and the Stieglitz collection are contained within the newly established George Eastman Archive and Study Center and the Richard and Ronay Menschel Library. These include correspondence, George Eastman's daybooks, Camera Club of New York minutes, various periodical titles including two complete runs of *Camera Work*, and books, articles, and pamphlets relating to Stieglitz. These materials are not included in this catalogue, but can be accessed by contacting staff from the appropriate collection in writing at: George Eastman House, 900 East Avenue, Rochester, New York, 14607, U.S.A.; or by telephone at: (716) 271-3361.

1. NOVEMBER DAYS (MUNICH, 1886)

1886
Transparency, gelatin on glass
(lantern slide)
6.4 x 4.9 cm.
GEH NEG: 13001
83:0660:0027
INSCRIPTION(S):
[on binder] [in ink] "November Days, (Munich, 1886)."
[in pencil] "58-A" "122"
[printed] "Alfred Stieglitz, New York."

2. A NOOK IN PALLANZA. (ITALY)

1887
Transparency, gelatin on glass
(lantern slide)
6.8 x 4.7 cm.
GEH NEG: 12983
83:0660:0009
INSCRIPTION(S):
[on binder] [in ink] "A Nook in Pallanza. (Italy)."
[printed] "Alfred Stieglitz"

3. MARIA (BELLAGIO)

1887
Transparency, gelatin on glass (lantern slide)
6.8 x 4.9 cm.
GEH NEG: 12981
83:0660:0007
INSCRIPTION(S):
[on binder] [in ink] "Maria (Bellagio, 1887) 1892." "69" "Soc. of Am. Photos N.Y." "88"
[in pencil] "63-A" "EK"
[printed] "Alfred Stieglitz"

4. MARINA

1887
Transparency, gelatin on glass
(lantern slide)
4.7 x 3.8 cm.
GEH NEG: 12988
83:0660:0014
INSCRIPTION(S):
[on binder] [in ink] "Marina." "1892"
[in pencil] "65E" "61"
[printed] "Alfred Stieglitz, New York."

5. VENETIAN BOY

[Published title: VENETIAN GAMIN]
1887/printed 1947 by
Lakeside Press, Chicago
Published by Twice a Year Press, New York
From: *Stieglitz Memorial Portfolio*, 1947
Photomechanical (halftone) reproduction
18.3 x 15.3 cm.
Museum purchase
GEH NEG: 48925
67:0120:0001
INSCRIPTION(S):
Recto–[printed lower right] "1"
NOTES:
Published title from *Photographs & Writings*.

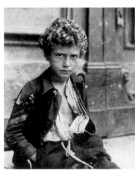

6. VENETIAN GAMIN

[Published title: VENETIAN BOY, 1887]
1887/print ca. 1924–1934
Gelatin silver print
18.5 x 14.9 cm.
GEH NEG: 1584
74:0052:0050
INSCRIPTION(S):
Verso–[in pencil] "58C" "A1"
NOTES:
Dated "1887" in list of plates for *Stieglitz Memorial Portfolio*, 1947.
Later print date from National Gallery of Art.

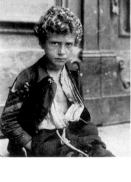

7. ON THE BRIDGE, CHIOGGIA

1887
Transparency, gelatin on glass
(lantern slide)
6.1 x 5.1 cm.
GEH NEG: 12980
83:0660:0006
INSCRIPTION(S):
[on binder] [in pencil] "59B"
[printed] "Alfred Stieglitz, New York."

8. SUNLIGHT AND SHADOWS—PAULA

[Published title: PAULA, BERLIN]
[Published title: SUN RAYS, PAULA, 1889]
1889/printed 1947 by Lakeside Press, Chicago
Published by Twice a Year Press, New York
From: *Stieglitz Memorial Portfolio*, 1947
Photomechanical (halftone) reproduction
20.8 x 15.2 cm.
Museum purchase
GEH NEG: 48926
67:0120:0002
INSCRIPTION(S):
Recto–[printed lower right] "2"

9. PAULA, BERLIN

[Published title: SUN RAYS, PAULA, BERLIN]
[Published title: SUNLIGHT AND SHADOW, PAULA, BERLIN]
1889/print ca. 1924–1934
Gelatin silver print
22.0 x 16.2 cm.
GEH NEGS: 28792, 3889
74:0052:0040
INSCRIPTION(S):
Verso–[print is backed with image] "Poplars, Lake George, 1932."
NOTES:
Print removed from original mount.
Later print date from National Gallery of Art.
Published title (1) from *Alfred Stieglitz: Photographer* and *Alfred Stieglitz: Photographs & Writings*. Published title (2) from *Alfred Stieglitz: An American Seer*.

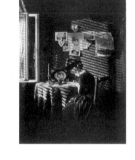

10. [Exhibition of photographic images and equipment]

ca. 1889
Transparency, gelatin on glass (lantern slide)
5.6 x 7.3 cm.
GEH NEG: 12999
83:0660:0025

11. JUBILEE EXHIBITION (BERLIN) MAIN HALL

1889
Transparency, gelatin on glass (lantern slide)
6.1 x 4.4 cm.
GEH NEG: 12990
83:0660:0016
INSCRIPTION(S):
[on binder] [in ink] "Jubilee Exh. (Berlin) Main Hall 1889."
[in pencil] "434-C" "EK"

12. [Peasant woman working in wheat field]

ca. 1890s
Transparency, gelatin on glass (lantern slide)
7.1 x 7.0 cm.
GEH NEG: 12987
83:0660:0013

13. AN IMPRESSION

1892
Transparency, gelatin on glass (lantern slide)
4.8 x 6.8 cm.
GEH NEG: 13007
83:0660:0033
INSCRIPTION(S):
[on binder] [in ink] "20. An Impression"
[in pencil] "127-E" "52-"
[printed] "Alfred Stieglitz, New York."

14. THE TERMINAL

1893/printed 1947 by Lakeside Press, Chicago
Published by Twice a Year Press, New York
From: *Stieglitz Memorial Portfolio*, 1947
Photomechanical (halftone) reproduction
20.3 x 26.7 cm.
Museum purchase
GEH NEG: 48927
67:0120:0003
INSCRIPTION(S):
Recto–[printed lower right] "3"

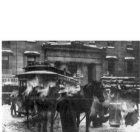

15. THE TERMINAL

1893/printed 1911 by
Manhattan Photogravure
Company, New York
From: *Camera Work*, No. 36,
October 1911
Photogravure print on Japan tissue
12.1 x 15.9 cm.
Museum purchase
GEH NEG: CW36:15
75:0011:0015
NOTES:
Title and date from list of plates, *Camera Work*.
Inscription in issue: "To make a silk purse out of a sow's ear, they say is an impossibility. 'Impossibilities' have always allured me. In making this book I have not entirely succeeded in realizing the silk purse—but remember the 'impossibility' I am attempting. To one who has suffered and understands—To my friend Kennerly—Alfred Stieglitz New York June 6/12"

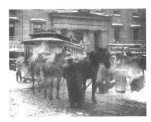

16. THE TERMINAL (NEW YORK)

1893
Transparency, gelatin on glass
(lantern slide)
6.5 x 7.5 cm.
GEH NEG: 12992
83:0660:0018

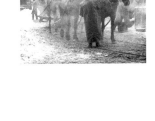

17. [Street paver beside smoking kettle]

1893
Transparency, gelatin on
glass (lantern slide)
3.4 x 6.7 cm.
GEH NEG: 12978
83:0660:0004
INSCRIPTION(S):
[on binder] [in ink] "Stieglitz. 18"
[in pencil] "120-E" "EK"

18. WINTER— FIFTH AVENUE

1893
Carbon print (?)
39.9 x 32.4 cm.
GEH NEG: 3871
72:0176:0001
INSCRIPTION(S):
Verso–[in pencil] "Winter—Fifth
Avenue (1892) by Alfred Stieglitz (New York)"

"Property OKeeffe [*sic*] [circled]" "Alfred Stieglitz"
"3W29" [various pencil notations—most partially obscured]

19. WINTER, FIFTH AVENUE, NEW YORK

1893/print ca. 1924–1934
Gelatin silver print
6.4 x 7.3 cm.
GEH NEG: 1408
74:0052:0039A
INSCRIPTION(S):
Mount verso–[in pencil] "124D"
NOTES:
Published date from *Camera Work*
Reproduction of image, cropped to form a vertical format, in *Alfred Stieglitz: An American Seer* and *Alfred Stieglitz: Photographs & Writings*. Dated on the basis of the latter. Later print date from National Gallery of Art.

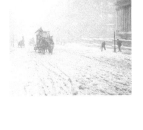

20. WINTER— FIFTH AVENUE

1893/print ca. 1924–1934
Gelatin silver print
6.5 x 8.8 cm.
GEH NEG: 17214
74:0052:0039B
INSCRIPTION(S):
Mount verso–[in pencil] "Winter—Fifth Ave 1893"
"E [circled]" "124D"
NOTES:
Reproduction of image, cropped to form a vertical format, in *Alfred Stieglitz: An American Seer* and *Alfred Stieglitz: Photographs & Writings*. Dated on the basis of the latter. Later print date from National Gallery of Art.

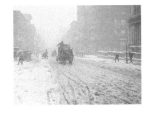

21. WINTER ON FIFTH AVENUE

[Published title: WINTER, FIFTH AVENUE]
1893/print ca. 1897
Published by R. H. Russell, New York
From portfolio: *Picturesque Bits of New York and Other Studies,* 1897
Photogravure print
28.4 x 22.1 cm.
Museum collection
GEH NEG: 26158
74:0054:0001
INSCRIPTION(S):
Recto–[printed above image] "Copyright 1897 by Alfred Stieglitz."

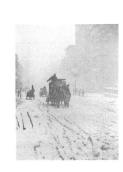

NOTES:

Dated 1893 in *Alfred Stieglitz: An American Seer*.

Dated 1892–93 in *Alfred Stieglitz, 1864–1946*.

Introduction to *Picturesque Bits of New York and Other Studies*, written by Walter E. Woodbury, author of *The Encyclopedia of Photography*.

Title from portfolio list of plates.

22. WINTER

[Published title: WINTER, FIFTH AVENUE]

1893/print ca. 1897

Published by the Vienna Camera Club

From: *Wiener Photographische Blatter*, Vol. IV, No. 1, January 1897

Photogravure print

17.3 x 13.8 cm.

Gift of Eastman Kodak Company Research Libraries

79:3088:0010

INSCRIPTION(S):

Verso–[in pencil] "Alfred Stieglitz. Winter" "263" "1897"

NOTES:

Published title from *Alfred Stieglitz: Photographs & Writings*.

23. WINTER, FIFTH AVENUE

1893

Transparency, gelatin on glass (lantern slide)

6.1 x 3.9 cm.

GEH NEG: 12993

83:0660:0019

INSCRIPTION(S):

[on binder] [in ink] "78. Winter, Fifth Avenue, I."

[printed] "Alfred Stieglitz, New York."

24. WINTER

[Published title: WINTER, FIFTH AVENUE, 1893]

1893/print ca. 1897

Published by the Vienna Camera Club

From: *Wiener Photographische Blatter*, Vol. IV, No. 1, January 1897

Photogravure print

17.3 x 13.8 cm.

Gift of Eastman Kodak Company Research Libraries

GEH NEG: 48994

87:1535:0001

INSCRIPTION(S):

[on cover sheet] "Winter." "Von Alfred Stieglitz."

NOTES:

Published title from *Alfred Stieglitz: Photographs & Writings*.

25. HANSOM CABS, CENTRAL PARK

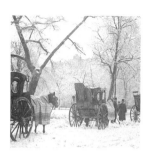

ca. 1894

Transparency, gelatin on glass (lantern slide)

6.8 x 6.8 cm.

GEH NEG: 12991

83:0660:0017

INSCRIPTION(S):

[on binder] [in pencil] "121-E" "EK"

26. [Carriage on wet boulevard]

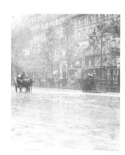

ca. 1894

Transparency, gelatin on glass (lantern slide)

6.2 x 5.1 cm.

GEH NEG: 13002

83:0660:0028

INSCRIPTION(S):

[on binder] [in pencil] "111 D EK"

27. [Mountain bridges]

ca. 1894

Transparency, gelatin on glass (lantern slide)

6.7 x 5.6 cm.

GEH NEG: 13000

83:0660:0026

INSCRIPTION(S):

[on binder] [in pencil] "113 B EK" "128"

[printed] "Alfred Stieglitz, New York."

28. THE INCOMING BOAT

ca. 1894

Published by R. H. Russell, New York

From portfolio: *Picturesque Bits of New York and Other Studies*, 1897

Photogravure print

16.2 x 13.3 cm.

Museum collection

GEH NEG: 48649

74:0054:0005

NOTES:

Introduction to *Picturesque Bits of New York and Other Studies*, written by Walter E. Woodbury, author of *The Encyclopedia of Photography*.

29. A WINTER SKY—CENTRAL PARK

1894
Published by R. H. Russell, New York
From portfolio: *Picturesque Bits of New York and Other Studies,* 1897
Photogravure print
21.7 x 16.9 cm.
Museum collection
GEH NEGS: 23334, 33720
74:0054:0002
INSCRIPTION(S):
Recto–[printed above image] "Copyright 1897 by Alfred Stieglitz."
NOTES:
Introduction to *Picturesque Bits of New York and Other Studies,* written by Walter E. Woodbury, author of *The Encyclopedia of Photography.*

30. A WET DAY ON THE BOULEVARD—PARIS

1894/print ca. 1897
Published by R. H. Russell, New York
From portfolio: *Picturesque Bits of New York and Other Studies,* 1897
Photogravure print
15.2 x 28.5 cm.
Museum collection
GEH NEG: 26029
74:0054:0004
INSCRIPTION(S):
Recto–[printed above image] "Copyright 1897 by Alfred Stieglitz"
NOTES:
Introduction to *Picturesque Bits of New York and Other Studies,* written by Walter E. Woodbury, author of *The Encyclopedia of Photography.*

31. WET DAY ON THE BOULEVARD, PARIS

1894
Carbon print
19.4 x 36.0 cm.
GEH NEG: 2787
74:0052:0082
INSCRIPTION(S):
Verso–[in pencil] "Photograph (carbon print) by Alfred Stieglitz 1894 Wet Day on the Boulevard, Paris"
"First photograph of the kind ever made(?)"

32. EIN NASSER TAG (A WET DAY)

[Published title: A WET DAY ON THE BOULEVARD—PARIS]
1894
Published by The Vienna Camera Club
From: *Wiener Photographische Blatter,* Vol. III, No. 8, August 1896
Photogravure print
9.0 x 15.9 cm.
Gift of Eastman Kodak Company Research Libraries
GEH NEG: 48939
87:1534:0016
INSCRIPTION(S):
[on cover sheet] "Ein Nasser Tag." "von Alfred Stieglitz."
NOTES:
Published title from *Picturesque Bits of New York and Other Studies.*

33. ON THE SEINE—NEAR PARIS

1894
Published by R. H. Russell, New York
From portfolio: *Picturesque Bits of New York and Other Studies,* 1897
Photogravure print
16.8 x 26.7 cm.
Museum collection
GEH NEG: 33742
74:0054:0009
INSCRIPTION(S):
Recto–[printed above image] "Copyright 1897 By Alfred Stieglitz."
NOTES:
Introduction to *Picturesque Bits of New York and Other Studies,* written by Walter E. Woodbury, author of *The Encyclopedia of Photography.*

34. ON THE SEINE—NEAR PARIS

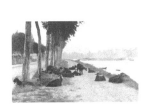

1894
Photogravure print
12.3 x 19.9 cm.
Museum purchase, ex-collection Dorothy Norman
GEH NEG: 48914
74:0052:0075A
INSCRIPTION(S):
Verso–[in pencil] "27" "A. Stieglitz Photogravure from album *Picturesque Bits of New York and Other Studies.*"
"Recd. Nov. 16/48 Twice A Year"

35. A VENETIAN WELL

1894
Transparency, gelatin on glass
(lantern slide)
6.2 x 6.8 cm.
GEH NEG: 13008
83:0660:0034
INSCRIPTION(S):
[on binder] [in ink] "A Venetian Well." "122"
[in pencil] "68-C" "1893"[sic]
[printed] "Alfred Stieglitz, New York."

36. GOSSIP—VENICE

1894/printed 1902
Published by The New York
Camera Club
From: *Camera Notes*, Vol. 6,
No. 1 (July 1902)
Photomechanical (halftone) reproduction
11.9 x 16.2 cm.
Museum collection
GEH NEG: 9501
73:0152:0002
INSCRIPTION(S):
[printed on cover sheet] "'Gossip—Venice.' From
a 'Glycerine' print by Alfred Stieglitz. (New York.)"

37. VENICE

[Published title: LAUNDRY,
VENICE]
1894/print ca. 1924–1934
Gelatin silver print
10.1 x 12.8 cm.
GEH NEG: 37392
74:0052:0035
INSCRIPTION(S):
Verso–[in pencil] "107A"
NOTES:
Published title from *Alfred Stieglitz: Photographer.*
Later print date from National Gallery of Art.

38. THE TWO FASHIONS, VENICE

1894
Transparency, gelatin on glass
(lantern slide)
6.8 x 6.8 cm.
GEH NEG: 12997
83:0660:0023
INSCRIPTION(S):
[on binder] [in ink] "The Two Fashions. Venice, 1894."
[printed] "Alfred Stieglitz, New York."

39. VENICE

1894
Transparency, gelatin on glass
(lantern slide)
6.4 x 6.8 cm.
GEH NEG: 13004
83:0660:0030
INSCRIPTION(S):
[on binder] [in ink] "Venice, 1894."
[in pencil] "87-E"
[printed] "Alfred Stieglitz, New York."

40. A VENETIAN CANAL

1894/print ca. 1897
Published by R. H. Russell, New York
From portfolio: *Picturesque Bits
of New York and Other Studies*, 1897
Photogravure print
26.5 x 18.4 cm.
Museum collection
GEH NEG: 26020
74:0054:0003
INSCRIPTION(S):
Recto–[printed above image] "Copyright 1897 by
Alfred Stieglitz."
NOTES:
Introduction to *Picturesque Bits of New York and
Other Studies*, written by Walter E. Woodbury,
author of *The Encyclopedia of Photography.*

41. A BIT OF VENICE

[Published title: A VENETIAN CANAL]
1894/print ca. 1924–1934
Gelatin silver print
22.2 x 16.2 cm.
GEH NEG: 5226
74:0052:0061
INSCRIPTION(S):
Verso–[in pencil] "58E"
NOTES:
Later print date from National Gallery of Art.
Published title from *In Focus: Alfred Stieglitz.*

42. VENETIAN CANAL

1894
Transparency, gelatin on glass
(lantern slide)
5.2 x 6.7 cm.
GEH NEG: 12986
83:0660:0012
INSCRIPTION(S):
[on binder] [in ink] "31. Venetian Canal."
[in pencil] "58E" "55 [lined out]" "26"

[printed] "Alfred Stieglitz, New York."
NOTES:
This image, cropped differently, was reproduced in portfolio,
Picturesque Bits of New York and Other Studies.

43. REFLECTIONS— VENICE

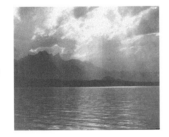

1894
Published by R. H. Russell,
New York
From portfolio: *Picturesque Bits
of New York and Other Studies*, 1897
Photogravure print
21.2 x 29.1 cm.
Museum collection
GEH NEG: 33741
74:0054:0012
INSCRIPTION(S):
Recto–[printed above image] "Copyright 1897 by
Alfred Stieglitz."
Verso–[in pencil] "Reflections Venice set of 12 hfl—
exx 1/3 ha 2/3 .75 G—1043"
NOTES:
Introduction to *Picturesque Bits of New York and
Other Studies*, written by Walter E. Woodbury,
author of *The Encyclopedia of Photography.*

44. [Lake and mountains]

1894
Transparency, gelatin on glass
(lantern slide)
6.1 x 3.9 cm.
GEH NEG: 12994
83:0660:0020

45. GRINDELWALD GLACIER

1894
Transparency, gelatin on glass
(lantern slide)
6.8 x 6.8 cm.
GEH NEG: 12975
83:0660:0001
INSCRIPTION(S):
[on binder] [in ink] "Grindelwald Glacier. 1894."
[in pencil] "112C EK"
[printed] "Alfred Stieglitz, New York."

46. THE JUNGFRAU FROM MURREN, SWISS

1894
Transparency, gelatin on glass
(lantern slide)
7.2 x 5.3 cm.
GEH NEG: 12989
83:0660:0015
INSCRIPTION(S):
[on binder] [in ink] "The Jungfrau from Murren, Swiss" "86"
[in pencil] "64-D"
[printed] "Alfred Stieglitz, New York." "The Camera Club, N.Y."

47. EXPERIMENT IN LOCAL TONING, GRINDELWALD GLACIER

1894
Transparency, gelatin on
glass (lantern slide)
5.3 x 6.8 cm.
GEH NEG: 12996
83:0660:0022
INSCRIPTION(S):
[on binder] [in ink] "31. Experiment in Local Toning."
[in pencil] "Grindelwald Glacier" "112-B" "E" "66"
[printed] "Alfred Stieglitz, New York."
See also 83:0660:0001 (cat. 45).

48. A BIT OF KATWIJK

1894
Transparency, gelatin on glass
(lantern slide)
5.2 x 6.0 cm.
GEH NEG: 12995
83:0660:0021
INSCRIPTION(S):
[on binder] [in ink] "83 A Bit of Katwijk"
[in pencil] "110 B 1893 [sic] EK"
[printed] "Alfred Stieglitz, New York." "The Camera Club, N.Y."

49. A DUTCH WOMAN

1894
Transparency, gelatin on glass
(lantern slide)
5.9 x 4.7 cm.
GEH NEG: 12985
83:0660:0011
INSCRIPTION(S):
[on binder] [in ink] "A Dutch Woman, 1894."
[in pencil] "65C"
[Printed label "Alfred Stieglitz, New York" is torn and
mostly missing.]

50. ON THE DYKES
1894
Transparency, gelatin on glass
(lantern slide)
5.1 x 6.9 cm.
GEH NEG: 13005
83:0660:0031
INSCRIPTION(S):
[on binder] [in ink] "On the Dykes, 1894"
[in pencil] "66-D" "122" "9 [circled]"
[printed] "Alfred Stieglitz, New York."

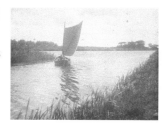

51. SCURRYING HOME
1894/print ca. 1924–1934
Gelatin silver print
7.8 x 10.2 cm.
GEH NEGS: 14589 9503
74:0052:0034
INSCRIPTION(S):
Mount verso–[in pencil] "Stieglitz, A. 'Scurrying Home'"
"60E" "18"
NOTES:
Later print date from National Gallery of Art.

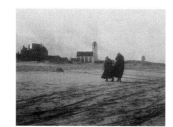

52. SCURRYING HOME
1894/print ca. 1897
Published by R. H. Russell, New York
From portfolio: *Picturesque Bits of
New York and Other Studies*, 1897
Photogravure print
18.0 x 14.8 cm.
Museum collection
GEH NEG: 33747
74:0054:0010
INSCRIPTION(S):
Recto–[printed above image] "Copyright 1897
by Alfred Stieglitz."
NOTES:
Introduction to *Picturesque Bits of New York and Other
Studies*, written by Walter E. Woodbury, author of
The Encyclopedia of Photography.
See also 74:0052:0034 (cat. 51) for variant.

53. NACH HAUSE (GOING HOME)
[Published title: SCURRYING HOME]
1894
Published by Photographische
Gesellschaft, Berlin
From: Franz Goerke, *Nach der Natur*,
Berlin: 1896, pl. 30.
Photogravure print

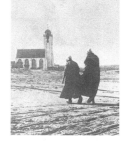

18.9 x 15.5 cm.
Museum purchase
GEH NEG: 33009
80:0177:0030
INSCRIPTION(S):
[on cover sheet] "30. Alfred Stieglitz, 'Nach Hause.'"
Recto–[printed] "Photographische Gesellschaft Berlin 1897
[*sic*]"

54. THE LETTER BOX
1894/print ca. 1897
Published by R. H. Russell, New York
From portfolio: *Picturesque Bits of
New York and Other Studies*, 1897
Photogravure print
19.7 x 14.5 cm.
Museum collection
GEH NEG: 20258
74:0054:0011
INSCRIPTION(S):
Recto–[printed above image] "Copyright 1895
by Alfred Stieglitz."
NOTES:
Introduction to *Picturesque Bits of New York and
Other Studies*, written by Walter E. Woodbury,
author of *The Encyclopedia of Photography*.

55. SUNDAY MORNING, GUTACH
1894
Transparency, gelatin on glass
(lantern slide)
6.8 x 6.8 cm.
GEH NEG: 12982
83:0660:0008
INSCRIPTION(S):
[on binder] [in ink] "Sunday Morning, Gutach. 1894"
[in pencil] "111B" "EK" "49"
[printed] "Alfred Stieglitz"

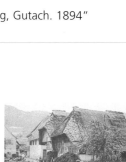

56. A STREET IN THE BLACK FOREST
1894/printed 1901
From: *The Photographic Times*,
1901
Photo-gelatin (collotype) print
10.7 x 15.5 cm.
Museum collection
73:0152:0001
INSCRIPTION(S):
Recto–[printed below image] "Photo-Gelatin Print by
The Albertype Co., Brooklyn, N.Y." "Alfred Stieglitz, 1894."
"A Street in the Black Forest."

57. THE OLD MILL

1894
Published by R. H. Russell, New York
From portfolio: *Picturesque Bits of
New York and Other Studies*, 1897
Photogravure print
27.8 x 20.2 cm.
Museum collection
GEH NEG: 33743
74:0054:0008
INSCRIPTION(S):
Recto–[printed above image] "Copyright 1897
by Alfred Stieglitz."
NOTES:
Introduction to *Picturesque Bits of New York and
Other Studies*, written by Walter E. Woodbury,
author of *The Encyclopedia of Photography*.

58. MOONLIGHT. OFF THE BATTERY, N.Y.

1895
Transparency, gelatin on glass
(lantern slide)
4.7 x 6.8 cm.
GEH NEG: 12977
83:0660:0003
INSCRIPTION(S):
[on binder] [in ink] "Moonlight. Off the Battery, N.Y. 1895"
[in pencil] "121-A" "13" "EK" "22"
[printed] "Alfred Stieglitz, New York."

59. IN ERWARTUNG DER HEIMKEHR (AWAITING THE RETURN HOME)

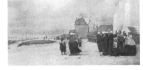

ca. 1896
Published by The Vienna Camera Club
From: *Wiener Photographische Blatter*, Vol. III, No. 10,
October 1896
Photogravure print
10.1 x 20.4 cm.
Gift of Eastman Kodak Company Research Libraries
GEH NEG: 48940
87:1534:0020
INSCRIPTION(S):
[on cover sheet] "In Erwartung Der Heimkehr."
"von Alfred Stieglitz."
[printed below image] "By Alfred Stieglitz"

60. REFLECTIONS, NIGHT—NEW YORK

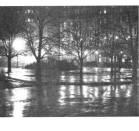
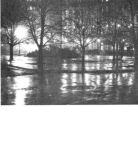

1896
Published by R. H. Russell,
New York
From portfolio: *Picturesque
Bits of New York and
Other Studies*, 1897
Photogravure print
21.0 x 27.2 cm.
Museum collection
GEH NEG: 15512
74:0054:0006
INSCRIPTION(S):
Recto–[printed above image] "Copyright 1897
by Alfred Stieglitz"
NOTES:
Introduction to *Picturesque Bits of New York and
Other Studies*, written by Walter E. Woodbury,
author of *The Encyclopedia of Photography*.

61. THE GLOW OF NIGHT—NEW YORK

1896
Published by R. H. Russell,
New York
From portfolio: *Picturesque Bits of New York
and Other Studies*, 1897
Photogravure print
12.1 x 23.4 cm.
Museum collection
GEH NEG: 25109
74:0054:0007
INSCRIPTION(S):
Recto–[printed above image] "Copyright 1897
by Alfred Stieglitz."
NOTES:
Introduction to *Picturesque Bits of New York and
Other Studies*, written by Walter E. Woodbury,
author of *The Encyclopedia of Photography*.

62. THE STREET— DESIGN FOR A POSTER

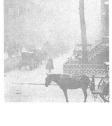

1896
Photogravure print
30.6 x 23.3 cm.
Museum purchase, ex-collection
Museum of Modern Art, New York
GEH NEGS: 9138, 2031
74:0052:0071
INSCRIPTION(S):
Verso–[in pencil] "A. Stieglitz: The Street:
Design for a Poster"

63. NIGHT—NEW YORK

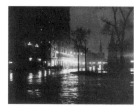

1897/printed 1947 by
Lakeside Press, Chicago
Published by Twice a Year
Press, New York
From: *Stieglitz Memorial Portfolio*, 1947
Photomechanical (halftone) reproduction
8.5 x 11.3 cm.
Museum purchase
GEH NEG: 48929
67:0120:0005
INSCRIPTION(S):
Recto–[printed lower right] "5"

64. NETZ—FLICKERIN

[Published title: MENDING NETS]
ca. 1898
Published by The Vienna
Camera Club
From: *Wiener Photographische
Blatter,* Vol. V, No. 5, May 1898
Photogravure print
10.7 x 14.6 cm.
Gift of Eastman Kodak Company Research Libraries
GEH NEG: 48941
87:1537:0012
INSCRIPTION(S):
Recto–[printed below image] "Alf. Stieglitz fec."
"Blechinger & Leykauf, hel. & imp." "Netz—Flickerin."

65. MENDING NETS

ca. 1898
From: *Camera Notes*, Vol. II, No. 3
(January 1899)
Photogravure print
11.2 x 15.6 cm.
Museum purchase
GEH NEG: 5208
89:0960:0003
INSCRIPTION(S):
Facing sheet–[letterpress] "'Mending Nets.'
By Alfred Stieglitz."

66. CENTRAL PARK (FROM MONTANT'S NEGATIVE)

Attributed to Alfred Stieglitz
1899
Transparency, gelatin on
glass (lantern slide)
7.0 x 6.1 cm.
GEH NEG: 12998
83:0660:0024
INSCRIPTION(S):
[on binder] [in ink] "...tral Park.
(from Montant's negative) 1899.-"
"10"
[in pencil] "113-E EK"
[printed] "Alfred Stieglitz, New York."

67. SPRING SHOWERS, NEW YORK

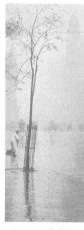

1901/printed 1911 by Manhattan
Photogravure Company, New York
From: *Camera Work*, No. 36, October 1911
Photogravure print on Japan tissue
23.0 x 9.2 cm.
Museum purchase
GEH NEG: CW36:16
75:0011:0016
NOTES:
Inscription in issue: "To make a silk purse
out of a sow's ear, they say is an impossibility. 'Impossibilities'
have always allured me. In making this book I have not
entirely succeeded in realizing the silk purse—but remember
the 'impossibility' I am attempting. To one who has suffered
and understands—To my friend Kennerly—Alfred Stieglitz
New York June 6/12"

68. SPRING SHOWERS

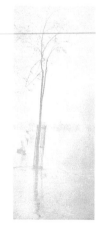

1901
Photogravure print
30.9 x 12.7 cm.
Museum purchase, ex-collection
Museum of Modern Art, New York
GEH NEG: 26187
74:0052:0062
INSCRIPTION(S):
Verso–[in pencil] "Spring Showers"

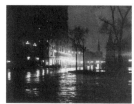

69. SPRING SHOWERS— NEW YORK

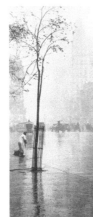

1901/printed 1947 by Lakeside
Press, Chicago
Published by Twice a Year Press, New York
From: *Stieglitz Memorial Portfolio*, 1947
Photomechanical (halftone) reproduction
9.6 x 4.0 cm.
Museum purchase
GEH NEG: 48928
67:0120:0004
INSCRIPTION(S):
Recto–[printed lower right] "4"

70. THE HAND OF MAN

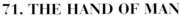

[Published title: THE HAND
OF MAN, NEW YORK]
1902/print ca. 1924–1934
Gelatin silver print
9.1 x 11.6 cm.
GEH NEG: 9137
74:0052:0084
INSCRIPTION(S):
Mount verso–[in pencil] "Ex 1932" "1" "123A"
NOTES:
Later print date from National Gallery of Art.

71. THE HAND OF MAN

[Published title: THE HAND
OF MAN (LONG ISLAND CITY,
NEW YORK)]
1902/printed 1911 by Manhattan
Photogravure Company, New York
From: *Camera Work*, No. 36, October 1911
Photogravure print on Japan tissue
15.9 x 21.4 cm.
Museum purchase
GEH NEG: CW36:13
75:0011:0013
NOTES:
Inscription in issue: "To make a silk purse out of a sow's
ear, they say is an impossibility. 'Impossibilities' have always
allured me. In making this book I have not entirely succeed-
ed in realizing the silk purse—but remember the 'impos-
sibility' I am attempting. To one who has suffered and
understands—To my friend Kennerly—Alfred Stieglitz
New York June 6/12"
Published title from *Alfred Stieglitz: Photographer*.

72. IN THE NEW YORK CENTRAL YARDS

1903/printed 1911 by Manhattan
Photogravure Company, New York
From: *Camera Work*, No. 36,
October 1911
Photogravure print on Japan tissue
19.4 x 15.9 cm.
Museum purchase
GEH NEG: CW36:14
75:0011:0014
NOTES:
Inscription in issue: "To make a silk purse out of a sow's
ear, they say is an impossibility. 'Impossibilities' have always
allured me. In making this book I have not entirely succeed-
ed in realizing the silk purse—but remember the 'impos-
sibility' I am attempting. To one who has suffered and
understands—To my friend Kennerly—Alfred Stieglitz
New York June 6/12"

73. PORTRAIT—S.R.

1904
From: *Camera Work*, No. 12, October
1905 or No. 41, January 1913
Photogravure print
20.7 x 14.0 cm.
Museum purchase with funds provided
by Eastman Kodak Company
GEH NEGS: 26035, 8470
74:0052:0070
NOTES:
Data is inconclusive as to whether this image was from the
1905 or the 1913 issue of *Camera Work*.

74. KATHERINE

1905
From: *Camera Work*, No. 12, October 1905
Photogravure print
20.9 x 16.8 cm.
Museum collection
GEH NEG: 9095
69:0252:0001

75. [Portrait of Alvin Langdon Coburn]

ca. 1905
Platinum print
23.6 x 18.5 cm.
Gift of Alvin Langdon Coburn
GEH NEG: 48272
67:0099:0121
INSCRIPTION(S):

Verso–[in pencil] "I plead 'not guilty.' Done in an irresponsible moment.—"[signed] "Alfred Stieglitz" "This is no work of art but a machine-made photograph"

76. [Portrait of Alvin Langdon Coburn]
ca. 1905
Platinum print
23.8 x 18.9 cm.
Gift of Alvin Langdon Coburn
GEH NEG: 47247
67:0099:0122

77. [Portrait of Alvin Langdon Coburn]
ca. 1905
Platinum print
24.5 x 19.3 cm.
Gift of Alvin Langdon Coburn
GEH NEG: 48271
67:0099:0123

78. THE SWIMMING LESSON
1906/printed 1911 by
Manhattan Photogravure
Company, New York
From: *Camera Work*, No. 36,
October 1911
Photogravure print on Japan tissue
14.8 x 23.1 cm.
Museum purchase
GEH NEG: CW36:11
75:0011:0011
NOTES:
Inscription in issue: "To make a silk purse out of a sow's ear, they say is an impossibility. 'Impossibilities' have always allured me. In making this book I have not entirely succeeded in realizing the silk purse—but remember the 'impossibility' I am attempting. To one who has suffered and understands—To my friend Kennerly—Alfred Stieglitz New York June 6/12"

79. [Hedwig Werner Stieglitz with red flower]
ca. 1907
Color plate, screen
(autochrome) process
16.3 x 11.3 cm.
74:0052:0078
NOTES:
Hedwig Werner Stieglitz was
Alfred Stieglitz's mother.

80. [Flower arrangement]
ca. 1907
Color plate, screen
(autochrome) process
11.6 x 9.1 cm.
Gift of Alfred E. Jurist
GEH NEG: 26114
74:0052:0081
OLD GEH NUMBER(S): 7031
NOTES:
[in original Autochrome plate box with French label]

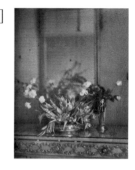

81. [Katherine Stieglitz with vase of flowers]
1907
Color plate, screen
(autochrome) process
16.4 x 11.7 cm.
GEH NEG: 26116
74:0052:0076

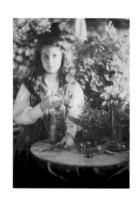

82. [Frank Eugene with stein of beer]
1907
Color plate, screen
(autochrome) process
16.3 x 11.5 cm.
GEH NEG: 26118
74:0052:0080

83. [Katherine Stieglitz and Elizabeth Stieglitz]
1907
Color plate, screen
(autochrome) process
11.5 x 16.5 cm.
GEH NEG: 26125
74:0052:0079

84. THE STEERAGE
1907/printed 1947 by Lakeside
Press, Chicago
Published by Twice a Year Press,
New York
From: *Stieglitz Memorial Portfolio*,
1947
Photomechanical (halftone)
reproduction
19.3 x 15.2 cm.

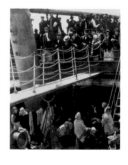

Museum purchase
GEH NEG: 48930
67:0120:0006
INSCRIPTION(S):
Recto–[printed lower right] "6"

85. THE STEERAGE

1907/print ca. 1915
From: *291*, September–October, 1915
Photogravure print on tissue
33.3 x 26.5 cm.
Museum purchase, ex-collection
Museum of Modern Art, New York
GEH NEG: 28796
74:0052:0064A

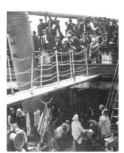

86. THE STEERAGE

1907/print ca. 1915
From: *291*, September–October, 1915
Photogravure print
33.3 x 26.5 cm.
Museum collection
74:0052:0064B

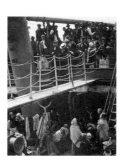

87. THE STEERAGE

1907
Photogravure print
32.7 x 26.0 cm.
Museum purchase, ex-collection
Museum of Modern Art, New York
GEH NEG: 28796
74:0052:0064C
INSCRIPTION(S):
Verso–[handwritten] "Eastman Historical Photographic
Collection-32"

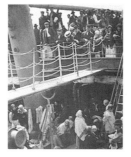

88. THE STEERAGE

1907/print ca. 1915
From: *291*, September–October, 1915
Photogravure print
33.3 x 26.4 cm.
Gift of Mrs. Gordon Taylor
GEH NEG: 19655
74:0052:0064D

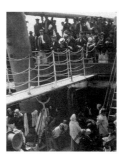

89. THE STEERAGE

1907/printed 1911 by Manhattan
Photogravure Company, New York
From: *Camera Work*, No. 36,
October 1911
Photogravure print on Japan tissue
19.7 x 15.8 cm.
Museum purchase
GEH NEG: CW36:9
75:0011:0009
NOTES:
Inscription in issue: "To make a silk purse out of a sow's
ear, they say is an impossibility. 'Impossibilities' have always
allured me. In making this book I have not entirely succeed-
ed in realizing the silk purse—but remember the 'impos-
sibility' I am attempting. To one who has suffered and
understands—To my friend Kennerly—Alfred Stieglitz
New York June 6/12"

90. JOSEPH T. KEILEY

1909
Platinum print
24.5 x 19.5 cm.
GEH NEG: 37382
74:0052:0056
INSCRIPTION(S):
Verso–[in pencil] "Joseph T. Keiley,
1909" "exhibition 1921" "33A"

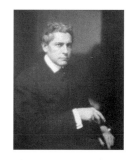

91. THE MAURETANIA

1910/print ca.1924–1934
Gelatin silver print
11.6 x 9.3 cm.
GEH NEG: 37394
74:0052:0085
INSCRIPTION(S):
Mount verso–[in pencil]
"The Mauretania 1910"
"4 [or H] [circled]" "124B" "D"
NOTES:
The *Mauretania* and its sister ship, the *Lusitania*, were
the biggest and fastest liners in the world when they
were built in 1906.
Later print date from National Gallery of Art.

92. THE MAURETANIA

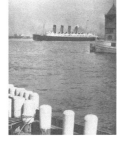

1910/printed 1911 by Manhattan
Photogravure Company, New York
From: *Camera Work*, No. 36,
October 1911
Photogravure print on Japan tissue
20.9 x 16.3 cm.
Museum purchase
GEH NEG: CW36:4
75:0011:0004
NOTES:

Inscription in issue: "To make a silk purse out of a sow's
ear, they say is an impossibility. 'Impossibilities' have always
allured me. In making this book I have not entirely suc-
ceeded in realizing the silk purse—but remember the
'impossibility' I am attempting. To one who has suffered
and understands—To my friend Kennerly—Alfred Stieglitz
New York June 6/12"

93. THE CITY OF AMBITION

1910/printed 1911 by Manhattan
Photogravure Company, New York
From: *Camera Work*, No. 36,
October 1911
Photogravure print on Japan tissue
22.2 x 16.8 cm.
Museum purchase
GEH NEG: CW36:1
75:0011:0001
NOTES:

Inscription in issue: "To make a silk purse out of a sow's
ear, they say is an impossibility. 'Impossibilities' have always
allured me. In making this book I have not entirely suc-
ceeded in realizing the silk purse—but remember the
'impossibility' I am attempting. To one who has suffered
and understands—To my friend Kennerly—Alfred Stieglitz
New York June 6/12"

94. CITY OF AMBITION

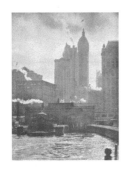

1910
Photogravure print
33.9 x 26.0 cm.
Museum purchase, ex-collection
Museum of Modern Art, New York
GEH NEG: 24104
74:0052:0072
INSCRIPTION(S):
Verso–[in pencil] "A. Stieglitz: City of Ambition"

95. THE CITY ACROSS THE RIVER

1910/printed 1911 by Manhattan
Photogravure Company, New York
From: *Camera Work*, No. 36,
October 1911
Photogravure print on Japan tissue
20.0 x 16.0 cm.
Museum purchase
GEH NEG: CW36:2
75:0011:0002
NOTES:

Inscription in issue: "To make a silk purse out of a sow's
ear, they say is an impossibility. 'Impossibilities' have always
allured me. In making this book I have not entirely suc-
ceeded in realizing the silk purse—but remember the
'impossibility' I am attempting. To one who has suffered
and understands—To my friend Kennerly —Alfred Stieglitz
New York June 6/12"

96. THE FERRY BOAT

1910/printed 1911 by Manhattan
Photogravure Company, New York
From: *Camera Work*, No. 36,
October 1911
Photogravure print on Japan tissue
20.9 x 16.3 cm.
Museum purchase
GEH NEG: CW36:3
75:0011:0003
NOTES:

Inscription in issue: "To make a silk purse out of a sow's
ear, they say is an impossibility. 'Impossibilities' have always
allured me. In making this book I have not entirely suc-
ceeded in realizing the silk purse—but remember the
'impossibility' I am attempting. To one who has suffered
and understands—To my friend Kennerly—Alfred Stieglitz
New York June 6/12"

97. LOWER MANHATTAN

1910/printed 1911 by Manhattan
Photogravure Company, New York
From: *Camera Work*, No. 36,
October 1911
Photogravure print
16.0 x 19.7 cm.
Museum purchase
GEH NEG: CW36:5
75:0011:0005
NOTES:

Inscription in issue: "To make a silk purse out of a sow's ear,
they say is an impossibility. 'Impossibilities' have always
allured me. In making this book I have not entirely suc-
ceeded in realizing the silk purse—but remember the

'impossibility' I am attempting. To one who has suffered and understands—To my friend Kennerly—Alfred Stieglitz New York June 6/12"

98. OLD AND NEW NEW YORK

1910/printed 1911 by Manhattan Photogravure Company, New York
From: *Camera Work*, No. 36, October 1911
Photogravure print on Japan tissue
20.3 x 15.8 cm.
Museum purchase
GEH NEG: CW36:6
75:0011:0006
NOTES:
Inscription in issue: "To make a silk purse out of a sow's ear, they say is an impossibility. 'Impossibilities' have always allured me. In making this book I have not entirely succeeded in realizing the silk purse—but remember the 'impossibility' I am attempting. To one who has suffered and understands—To my friend Kennerly—Alfred Stieglitz New York June 6/12"

99. THE AEROPLANE

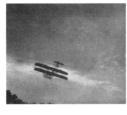

1910/printed 1911 by Manhattan Photogravure Company, New York
From: *Camera Work*, No. 36, October 1911
Photogravure print on Japan tissue
14.4 x 17.4 cm.
Museum purchase
GEH NEG: CW36:7
75:0011:0007
NOTES:
Inscription in issue: "To make a silk purse out of a sow's ear, they say is an impossibility. 'Impossibilities' have always allured me. In making this book I have not entirely succeeded in realizing the silk purse—but remember the 'impossibility' I am attempting. To one who has suffered and understands—To my friend Kennerly—Alfred Stieglitz New York June 6/12"

100. THE DIRIGIBLE

1910/printed 1911 by Manhattan Photogravure Company, New York
From: *Camera Work*, No. 36, October 1911
Photogravure print on Japan tissue
17.8 x 17.9 cm.
Museum purchase
GEH NEG: CW36:8
75:0011:0008

NOTES:
Inscription in issue: "To make a silk purse out of a sow's ear, they say is an impossibility. 'Impossibilities' have always allured me. In making this book I have not entirely succeeded in realizing the silk purse—but remember the 'impossibility' I am attempting. To one who has suffered and understands—To my friend Kennerly—Alfred Stieglitz New York June 6/12"

101. THE POOL— DEAL

1910/printed 1911 by Manhattan Photogravure Company, New York
From: *Camera Work*, No. 36, October 1911
Photogravure print on Japan tissue
12.6 x 15.9 cm.
Museum purchase
GEH NEG: CW36:12
75:0011:0012
NOTES:
Inscription in issue: "To make a silk purse out of a sow's ear, they say is an impossibility. 'Impossibilities' have always allured me. In making this book I have not entirely succeeded in realizing the silk purse—but remember the 'impossibility' I am attempting. To one who has suffered and understands—To my friend Kennerly—Alfred Stieglitz New York June 6/12"

102. EXCAVATING— NEW YORK

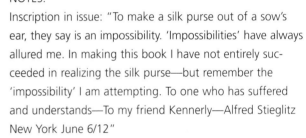

1911/print ca. 1924–1934
Gelatin silver print
8.7 x 11.6 cm.
GEH NEG: 10203
74:0052:0038
INSCRIPTION(S):
Mount verso–[in pencil] "126C"
NOTES:
Later print date from National Gallery of Art.

103. EXCAVATING— NEW YORK

1911/printed 1911 by Manhattan Photogravure Company, New York
From: *Camera Work*, No. 36, October 1911
Photogravure print on Japan tissue
12.7 x 15.8 cm.
Museum purchase
GEH NEG: CW36:10
75:0011:0010

NOTES:

Inscription in issue: "To make a silk purse out of a sow's ear, they say is an impossibility. 'Impossibilities' have always allured me. In making this book I have not entirely succeeded in realizing the silk purse—but remember the 'impossibility' I am attempting. To one who has suffered and understands—To my friend Kennerly—Alfred Stieglitz New York June 6/12"

104. A SNAPSHOT, PARIS

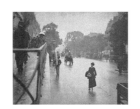

1911/print 1913 by Manhattan Photogravure Company, New York
From: *Camera Work*, No. 41, January 1913
Photogravure print
13.8 x 17.4 cm.
GEH NEG: 9367
74:0052:0068

105. KONRAD CRAMER AT 291

1914
Platinum print
24.5 x 19.8 cm.
Gift of Mrs. Gordon Taylor
GEH NEG: 13417
74:0052:0057

106. 291
[Konrad Cramer at 291]

1914
Platinum print
25.2 x 20.2 cm.
Gift of Mrs. Gordon Taylor
GEH NEG: 13422
74:0052:0058
INSCRIPTION(S):
Verso–[in pencil, below image] "'291'" "1914."
"Mr. Conrad [*sic*] Cramer Woodstock N.Y." "Paid 4 25 [underlined]" "value $100.00 Insured" "+8 1/2 2363 White Bass (illeg.)" "Bx 35" "R. 14 x 18 1/2"
NOTES:
See *PSA Journal* (Vol. 13, November 1947) for dating image as "1912" with description, by Cramer, of having portrait made by Stieglitz.

107. [Katherine Stieglitz with tennis racquet]

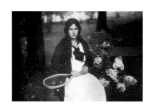

ca. 1915
Color plate, screen (autochrome) process
11.8 x 16.8 cm.
GEH NEG: 26121
74:0052:0077

108. [Portrait of Marie Rapp (Boursault)]

1915
Color plate, screen (autochrome) process
9.0 x 9.4 cm. (visible)
Museum purchase
GEH NEG: 48993
74:0097:0001
INSCRIPTION(S):
[accompanying note] "this Lumiere Autochrome portrait was made of me by Alfred Stieglitz—at '291' in 1915 [signed] Marie Rapp Boursault, April 26, 1974"
NOTES:
Marie Rapp (Boursault) was Stieglitz's assistant at 291.

109. ABRAHAM WALKOWITZ

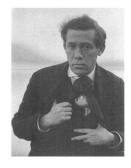

1916
Platinum print
24.3 x 19.4 cm.
GEH NEG: 37379
74:0052:0054
INSCRIPTION(S):
Verso–[in pencil] "54C"

110. ELLEN KOENIGER, LAKE GEORGE

1916
Gelatin silver print
10.9 x 8.5 cm.
GEH NEG: 10201
74:0052:0042
INSCRIPTION(S):
Verso–[in pencil] "235B" "A"
NOTES:
Title from *Alfred Stieglitz at Lake George*.

111. GEORGIA O'KEEFFE

1918
Gelatin silver print
9.0 x 11.7 cm.
GEH NEG: 10206
74:0052:0045
INSCRIPTION(S):
Verso–[in pencil] "OK 507A"

112. GEORGIA O'KEEFFE

1918
Palladium print
9.1 x 11.5 cm.
GEH NEG: 22319
74:0052:0044
INSCRIPTION(S):
Verso–[in pencil] "OK 514A" "treated 2/50" "D"

113. GEORGIA O'KEEFFE

1918
Palladium print
23.9 x 17.9 cm.
GEH NEG: 1539
74:0052:0063
INSCRIPTION(S):
Verso–[in pencil] "OK 25-E"
"Alfred Stieglitz"

114. GEORGIA O'KEEFFE [Hand]

1918
Gelatin silver print
10.5 x 8.3 cm.
GEH NEG: 8665
74:0052:0048
INSCRIPTION(S):
Verso–[in pencil] "D"

115. DOROTHY TRUE

1919
Palladium print
25.1 x 20.2 cm.
GEH NEG: 37384
74:0052:0053
INSCRIPTION(S):
Recto–[on mount, in pencil]
"Treated 6/50"
Verso–[in pencil] "E" "40C" "smooth" "rough [lined out]"
"H" "x" "W"

116. DOROTHY TRUE

1919
Palladium print
25.3 x 20.1 cm.
GEH NEG: 37380
74:0052:0060
INSCRIPTION(S):
Verso–[in pencil] "E" "40A"
Recto–[below image, on mount]
"Treated 6/50"

117. [Georgia O'Keeffe and Donald Davidson pruning trees]

1920
Gelatin silver print
9.1 x 11.8 cm.
GEH NEG: 10204
74:0052:0043
INSCRIPTION(S):
Verso–[in pencil] "R" "10x12-1/2"

118. GEORGIA O'KEEFFE

1920
Gelatin silver print
11.5 x 8.8 cm.
GEH NEGS: 22317, 5558
74:0052:0046
INSCRIPTION(S):
Verso–[in pencil] "OK 513B"

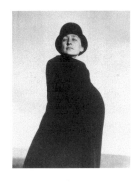

119. GEORGIA O'KEEFFE

1920
Platinum print
25.6 x 20.0 cm.
GEH NEGS: 37385, 1541
74:0052:0092
INSCRIPTION(S):
Verso–[in pencil] "OK 18C" "E"

120. O'KEEFFE HANDS AND THIMBLE

1920/printed 1947 by Lakeside
Press, Chicago
Published by Twice a Year Press,
New York
From: *Stieglitz Memorial Portfolio*,
1947
Photomechanical (halftone) reproduction
19.7 x 15.3 cm.

Museum purchase
GEH NEG: 48932
67:0120:0009
INSCRIPTION(S):
Recto–[printed lower right] "9"
NOTES:
Dated "1920" in *Georgia O'Keeffe: A Portrait by Alfred Stieglitz.*

121. PORTRAIT—JOHN MARIN

1922/printed 1947 by Lakeside
Press, Chicago
Published by Twice a Year Press,
New York
From: *Stieglitz Memorial Portfolio*,
1947
Photomechanical (halftone)
reproduction
19.9 x 15.2 cm.
Museum purchase
GEH NEG: 48931
67:0120:0007
INSCRIPTION(S):
Recto–[printed lower right] "7"

122. APPLES AND GABLE, LAKE GEORGE

1922
Gelatin silver print
11.4 x 9.1 cm.
GEH NEG: 5500
74:0052:0069
INSCRIPTION(S):
Verso–[in pencil] "51"

123. CLOUDS, MUSIC NO. 1, LAKE GEORGE

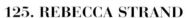

[Published title: MUSIC—
A SEQUENCE OF TEN CLOUD
PHOTOGRAPHS, NO. 1]
1922
Palladium print
20.1 x 25.3 cm.
GEH NEG: 8662
74:0052:0067
INSCRIPTION(S):
Recto–[on mount, in pencil] "Treated by Steichen for S.
[illeg.] 5/49" [on mount, under image] "Peabody House"
Verso–[in pencil] "27B"
NOTES:
Published title from *Alfred Stieglitz: Photographs & Writings*
and *Alfred Stieglitz at Lake George.*

Research has indicated that it was in 1922 that Stieglitz
produced his first series of images of clouds titled "Music—
A Sequence of Ten Cloud Photographs." [Christie's,
New York, "Photographs," 29 April 1999 auction
catalogue, p. 176]

124. GEORGIA O'KEEFFE

1922
Platinum print
20.1 x 25.0 cm.
GEH NEGS: 3607, 1969
74:0052:0015
INSCRIPTION(S):
Verso–[in pencil] "E" "OK 10A" "16"
NOTES:
Dated "1930" in *Picture History of Photography.*

125. REBECCA STRAND

1922
Gelatin silver print
23.7 x 19.0 cm.
GEH NEGS: 37386, 8663
74:0052:0096
INSCRIPTION(S):
Verso–[in pencil] "92A"
"Rebecca Strand"

126. BARN—LAKE GEORGE

ca. 1923/printed 1947 by
Lakeside Press, Chicago
Published by Twice a Year
Press, New York
From: *Stieglitz Memorial Portfolio*, 1947
Photomechanical (halftone) reproduction
15.2 x 19.3 cm.
Museum purchase
GEH NEG: 48933
67:0120:0011
INSCRIPTION(S):
Recto–[printed lower right] "11"

127. PORTRAIT OF R.

[Published title: REBECCA STRAND]
1923
Gelatin silver print
9.3 x 11.9 cm.
GEH NEG: 8664
74:0052:0087
INSCRIPTION(S):
Mount verso–[in pencil] "214B"

NOTES:
Image is reversed from reproduction in *Alfred Stieglitz: Photographer* and *Alfred Stieglitz at Lake George*. Variant image titled "Rebecca Strand, 1922–1923" reproduced in *Alfred Stieglitz: Photographs & Writings*. Published title from *Alfred Stieglitz: Photographer* and *Alfred Stieglitz at Lake George*.

128. GEORGIA O'KEEFFE

1923
Gelatin silver print
11.7 x 9.1 cm.
GEH NEG: 26993
74:0052:0047
INSCRIPTION(S):
Verso–[in pencil] "OK 509B"

129. SPIRITUAL AMERICA

[Published title: SPIRITUAL AMERICA, NEW YORK]
1923
Gelatin silver print
11.6 x 9.1 cm.
GEH NEG: 5501
74:0052:0041
INSCRIPTION(S):
Mount verso–[in pencil] "Stieglitz, Alfred 'Spiritual America' 1923." "O'Keefe [*sic*] # 155C."
NOTES:
Published title from *Alfred Stieglitz: An American Seer*.

130. PAUL ROSENFELD

1923
Gelatin silver print
22.4 x 18.6 cm.
GEH NEG: 37381
74:0052:0049
INSCRIPTION(S):
Verso–[in pencil] "33B"

131. EQUIVALENT

1923
From series: *Equivalents*
Gelatin silver print
11.6 x 9.0 cm.
GEH NEG: 48912
74:0052:0029
INSCRIPTION(S):
Mount verso–[in pencil] "231-B"
NOTES:
See 74:0052:0030 (cat. 132) for same image presented horizontally.

132. EQUIVALENT

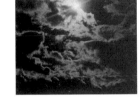

1923
From series: *Equivalents*
Gelatin silver print
9.3 x 11.8 cm.
GEH NEG: 5511
74:0052:0030
INSCRIPTION(S):
Mount verso–[in pencil] "231B"
NOTES:
See also 74:0052:0029 for same image presented vertically.

133. EQUIVALENT

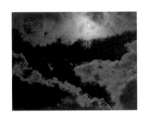

1923
From series: *Equivalents*
Gelatin silver print
9.3 x 11.6 cm.
GEH NEG: 8696
74:0052:0007
INSCRIPTION(S):
Mount verso–[in pencil] "156-E [underlined]"

134. EQUIVALENT

1923
From series: *Equivalents*
Gelatin silver print
9.2 x 11.8 cm.
GEH NEG: 9166
74:0052:0011
INSCRIPTION(S):
Mount verso–[in pencil] "162C" "15"

135. EQUIVALENT

1923
From series: *Equivalents*
Gelatin silver print
11.6 x 9.2 cm.
GEH NEG: 9180
74:0052:0022
INSCRIPTION(S):
Mount verso–[in pencil] "161-C [underlined]"

136. MOUNTAIN AND SKY—LAKE GEORGE

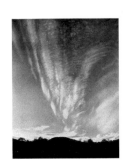

1924/printed 1947 by
Lakeside Press, Chicago
Published by Twice a Year
Press, New York
From: *Stieglitz Memorial Portfolio*, 1947
Photomechanical (halftone) reproduction
19.5 x 15.4 cm.
Museum purchase

GEH NEG: 26997
67:0120:0008
INSCRIPTION(S):
Recto–[printed lower right] "8"

137. EQUIVALENT
1924
From series: *Equivalents*
Gelatin silver print
9.1 x 11.9 cm.
GEH NEG: 9176
74:0052:0025
INSCRIPTION(S):
Mount verso–[in pencil] "178E"

138. EQUIVALENT
[Published title: EQUIVALENT,
1926 (?)]
[Published title: SONGS OF
THE SKY, 1924]
1924–1925
From series: *Equivalents*
Gelatin silver print
9.4 x 12.0 cm.
GEH NEGS: 37391, 8695
74:0052:0090
INSCRIPTION(S):
Verso–[in pencil] "155B" "1924 [underlined]"
"1925 [underlined]"
NOTES:
Published titles and dates from *Alfred Stieglitz: Photographer*
and *Georgia O'Keeffe & Alfred Stieglitz, Two Lives*.

139. EQUIVALENT
1925
From series: *Equivalents*
Gelatin silver print
9.3 x 11.9 cm.
GEH NEG: 8694
74:0052:0089
INSCRIPTION(S):
Mount verso–[in pencil] "144A" "DD"

140. EQUIVALENT
1925
From series: *Equivalents*
Gelatin silver print
11.8 x 9.2 cm.
GEH NEG: 5504
74:0052:0010
INSCRIPTION(S):
Mount verso–[in pencil] "171E"

141. EQUIVALENT
1925
From series: *Equivalents*
Gelatin silver print
11.8 x 9.2 cm.
GEH NEG: 9171
74:0052:0006
INSCRIPTION(S):
Verso–[in pencil] "170E" "Equ [lined
out]" "Top [underlined]" "Equivalent—
1925" [signed] "Alfred Stieglitz
[underlined]" "1925" "3"

142. EQUIVALENT
[Published title: AN EQUIVALENT
IN A SERIES OF TWO EQUIVALENTS,
PRINT X, 1923–1938]
1925
From series: *Equivalents*
Gelatin silver print
11.8 x 9.2 cm.
GEH NEG: 9169
74:0052:0024
INSCRIPTION(S):
Verso–[in pencil] "169B" "A1"
NOTES:
Published title from *Alfred Stieglitz at Lake George*.

143. EQUIVALENT
1925
From series: *Equivalents*
Gelatin silver print
9.3 x 11.8 cm.
GEH NEG: 9177
74:0052:0021
INSCRIPTION(S):
Verso–[in pencil] "168E"

144. EQUIVALENT
1925
From series: *Equivalents*
Gelatin silver print
11.8 x 9.3 cm.
GEH NEG: 8693
74:0052:0009
INSCRIPTION(S):
Verso–[in pencil] "170A" "1925" x
"D"

145. EQUIVALENT

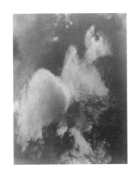

1925
From series: *Equivalents*
Gelatin silver print
11.6 x 9.0 cm.
GEH NEG: 9168
74:0052:0018
INSCRIPTION(S):
Verso–[in pencil] "170C"

146. EQUIVALENT

1925–1926
From series: *Equivalents*
Gelatin silver print
9.2 x 11.8 cm.
GEH NEG: 8692
74:0052:0008
INSCRIPTION(S):
Mount verso–[in pencil] "179A" "Top [underlined]"
"1925 (26)"
NOTES:
Pencil notation verso possibly dates image to 1925 or 1926.

147. EQUIVALENT

1926
From series: *Equivalents*
Gelatin silver print
11.8 x 9.2 cm.
GEH NEG: 9173
74:0052:0088
INSCRIPTION(S):
Verso–[in pencil] "177E"

148. EQUIVALENT

1926
From series: *Equivalents*
Gelatin silver print
9.2 x 11.8 cm.
GEH NEG: 9170
74:0052:0032
INSCRIPTION(S):
Verso–[in pencil] "228D" "1926"

149. EQUIVALENT

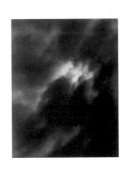

[Published title: EQUIVALENT,
1927–29 (?)]
[Published title: EQUIVALENT,
1929 (?)]
1926
 From series: *Equivalents*
 Gelatin silver print
 11.6 x 9.2 cm.

GEH NEG: 25952
74:0052:0091
INSCRIPTION(S):
Verso–[in pencil] "175A" "1926" "D"
NOTES:
Published titles from *Alfred Stieglitz: An American Seer* and
Alfred Stieglitz: Photographer.

150. EQUIVALENT

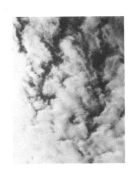

1926
From series: *Equivalents*
Gelatin silver print
11.8 x 9.2 cm.
GEH NEG: 48913
74:0052:0028
INSCRIPTION(S):
Verso–[in pencil] "229D"

151. DEAD TREE— LAKE GEORGE

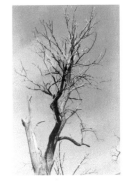

ca. 1927
Gelatin silver print
23.1 x 15.1 cm.
Gift of Dorothy Norman
68:0027:0002
INSCRIPTION(S):
Verso–[in pencil] "Dead Tree—
Lake George 1934 [*sic*]. Also called
'Life and Death' by Stieglitz
Verso–[original backing, in ink] "For Mrs. Louis Steichen from
Alfred Stieglitz [name underlined] who is eternally in debt to
her & her husband An American Place Jan. 24-1938" [in
pencil] "Original by Alfred Stieglitz inscribed to Dorothy
Norman's mother [*sic*] by A.S. in his handwriting" "For
Philadelphia Museum Collection Dorothy Norman
[lined out]" "given by Mrs. Steichen to Dorothy Norman"
NOTES:
In a letter accompanying the donation of this work to the
Eastman House, Dorothy Norman states that she was "mak-
ing this gift... to honor the extraordinarily fine work that Mr.
Newhall continues to do. I want you to know how much I
admire his scholarship as well as all of his other fine quali-
ties." [Dorothy Norman to Dr. Cyril Stoud, March 4, 1968]

152. EQUIVALENT

1927
From series: *Equivalents*
Gelatin silver print
9.1 x 11.9 cm.
GEH NEG: 9175
74:0052:0027
INSCRIPTION(S):
Verso–[in pencil] "178D" "Top" "A+" "1 [underlined]"
"DO" "Poh (?), 1927"

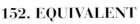

153. EQUIVALENT

1927

From series: *Equivalents*

Gelatin silver print

9.3 x 11.9 cm.

GEH NEG: 8697

74:0052:0004

INSCRIPTION(S):

Verso–[in pencil] "221E" "D"

154. EQUIVALENT

1929

From series: *Equivalents*

Gelatin silver print

11.9 x 9.3 cm.

GEH NEG: 9174

74:0052:0031

INSCRIPTION(S):

Verso–[in pencil] "225-D [underlined]"

"Set 2 1929 [underlined]" "no. 3"

NOTES:

Listed in museum acquisition documents as "Set A, 2nd set of A, print 3."

155. EQUIVALENT

1929

From series: *Equivalents*

Gelatin silver print

11.8 x 9.2 cm.

GEH NEG: 9178

74:0052:0023

INSCRIPTION(S):

Verso–[in pencil] "225-C [underlined]" "Set 2 1929 [underlined]" "no. 2" [marked out] "Set 2 1929 no. 3"

NOTES:

Listed in museum acquisitions documents as "Set A, 2nd set of A, print 2."

156. EQUIVALENT

1929

From series: *Equivalents*

Gelatin silver print

9.3 x 11.9 cm.

GEH NEG: 9167

74:0052:0026

INSCRIPTION(S):

Verso–[in pencil] "225-E" "Set 2 1929 [underlined]" "no. 4"

NOTES:

Listed in museum acquisition documents as "Set A, 2nd set of A, print 4."

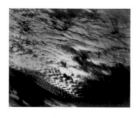

157. EQUIVALENT

1929

From series: *Equivalents*

Gelatin silver print

12.0 x 9.3 cm.

GEH NEG: 8691

74:0052:0017

INSCRIPTION(S):

Verso–[in pencil] "226-A [underlined]"

"Set 2 1929 [underlined]" "no. 5"

NOTES:

Listed in museum acquisitions documents as "Set A, 2nd set of A, print 5."

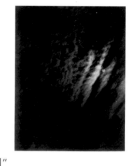

158. EQUIVALENT

[Published title: EQUIVALENT, SERIES 20, NO. 9, 1929]

1929

From series: *Equivalents*

Gelatin silver print

11.9 x 9.2 cm.

GEH NEG: 8699

74:0052:0012

INSCRIPTION(S):

Verso–[in pencil] "226-B [underlined]"

"Set 2 1929 [underlined]" "no. 6" "1929"

NOTES:

Listed in museum acquisitions documents as "Set A, 2nd set of A, print 6"

Published title from *Georgia O'Keeffe & Alfred Stieglitz, Two Lives.*

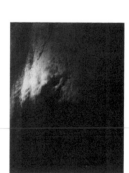

159. EQUIVALENT

1929

From series: *Equivalents*

Gelatin silver print

12.0 x 9.3 cm.

GEH NEG: 9165

74:0052:0014

INSCRIPTION(S):

Verso–[in pencil] "226C [underlined]"

"Set 2 1929 [underlined]" "no. 7"

NOTES:

Listed in museum acquisitions documents as "Set A, 2nd set of A, print 7."

160. EQUIVALENT

1929

From series: *Equivalents*

Gelatin silver print

11.8 x 9.3 cm.

GEH NEG: 9172

74:0052:0020

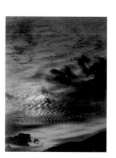

161. PORTRAIT— GEORGIA O'KEEFFE

1929/printed 1947 by
Lakeside Press, Chicago
Published by Twice a Year Press,
New York
From: *Stieglitz Memorial Portfolio*,
1947
Photomechanical (halftone) reproduction
18.8 x 15.2 cm.
Museum purchase
GEH NEG: 27005
67:0120:0010
INSCRIPTION(S):
Recto–[printed lower right] "10"

162. LAKE GEORGE

ca. 1930
Gelatin silver print
11.0 x 8.6 cm.
GEH NEG: 37393
74:0052:0033
INSCRIPTION(S):
Verso–[in pencil] "193A"

163. GEORGIA O'KEEFFE

1930
Gelatin silver print
23.6 x 19.1 cm.
GEH NEG: 3647
74:0052:0052

164. GEORGIA O'KEEFFE

[Published title: HANDS
WITH SKULL]
1930
Gelatin silver print
16.9 x 23.1 cm.
GEH NEG: 10209
74:0052:0055
Published title from *Alfred Stieglitz: An American Seer.*

165. EQUIVALENT

1930
From series: *Equivalents*
Gelatin silver print
9.3 x 11.8 cm.
GEH NEG: 8667
74:0052:0003
INSCRIPTION(S):
Verso–[in pencil] "177A"

166. EQUIVALENT

1930
From series: *Equivalents*
Gelatin silver print
9.2 x 11.9 cm.
GEH NEG: 8698
74:0052:0005
INSCRIPTION(S):
Verso–[in pencil] "176D" "1930" "x"

167. EQUIVALENT

1930
From series: *Equivalents*
Gelatin silver print
11.9 x 9.2 cm.
GEH NEG: 5502
74:0052:0002
INSCRIPTION(S):
Mount verso– "175C" "3S"

168. EQUIVALENT— SERIES 107

1931/printed 1947 by
Lakeside Press, Chicago
Published by Twice a Year Press,
New York
From: *Stieglitz Memorial Portfolio*,
1947
Photomechanical (halftone)
reproduction
11.6 x 9.0 cm.
Museum purchase
GEH NEG: 48935
67:0120:0014
INSCRIPTION(S):
Recto–[printed lower right] "14"

169. EQUIVALENT 27C

1931/printed 1947 by Lakeside
Press, Chicago
Published by Twice a Year Press,
New York
From: *Stieglitz Memorial Portfolio*,
1947
Photomechanical (halftone)
reproduction
20.7 x 16.5 cm.
Museum purchase
GEH NEG: 26996
67:0120:0018
INSCRIPTION(S):
Recto–[printed lower right] "18"

170. SKY

[Published title: EQUIVALENT]
1931/printed 1947 by Lakeside
Press, Chicago
Published by Twice a Year Press,
New York
From: *Stieglitz Memorial Portfolio*,
1947
Photomechanical (halftone)
reproduction
11.7 x 9.2 cm.
Museum purchase
GEH NEG: 48937
67:0120:0016
INSCRIPTION(S):
Recto–[printed lower right] "16"
NOTES:
Published title from *Photography & Writings* and
Alfred Stieglitz at Lake George.

171. EQUIVALENT

1931
From series: *Equivalents*
Gelatin silver print
11.8 x 9.0 cm.
GEH NEG: 4367
74:0052:0016
INSCRIPTION(S):
Verso–[in pencil] "149-A" "Ex 1932"
"Equivalent, about 1931" [in blue pencil] "S [circled]"
NOTES:
Dated "about 1931" in *Masters of Photography*.

172. EQUIVALENT

1931
From series: *Equivalents*
Gelatin silver print
11.9 x 9.0 cm.
GEH NEG: 5505
74:0052:0013
INSCRIPTION(S):
Verso–[in pencil] "225A"

173. EQUIVALENT

1931
From series: *Equivalents*
Gelatin silver print
11.9 x 9.3 cm.
GEH NEG: 9179
74:0052:0019
INSCRIPTION(S):
Verso–[in pencil] "145D"

174. DOROTHY NORMAN

1931
Gelatin silver print
11.6 x 9.0 cm.
GEH NEG: 37390
74:0052:0094
INSCRIPTION(S):
Verso–[in pencil] "246C"

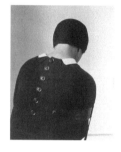

175. FROM MY WINDOW AT THE SHELTON, WEST, 1931

1931
Gelatin silver print
23.7 x 19.0 cm.
GEH NEGS: 20526, 5522
74:0052:0073
INSCRIPTION(S):
Verso–[in pencil] "2C"
NOTES:
Title and date from *Alfred Stieglitz: Photographs & Writings*.
Variant images reproduced in *Alfred Stieglitz: An American
Seer* and *Alfred Stieglitz: Photographer*, both dated 1932.

176. EVENING FROM THE SHELTON

1931/printed 1947 by Lakeside
Press, Chicago
Published by Twice a Year Press,
New York
From: *Stieglitz Memorial Portfolio*,
1947

Photomechanical (halftone) reproduction
20.9 x 16.6 cm.
Museum purchase
GEH NEG: 40689
67:0120:0012
INSCRIPTION(S):
Recto–[printed lower right] "12"

177. FROM AN AMERICAN PLACE, LOOKING NORTH

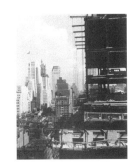

1931
Gelatin silver print
24.1 x 19.1 cm.
GEH NEG: 37388
74:0052:0086
INSCRIPTION(S):
Verso–[in pencil] "9B" "M [circled]"

178. DOROTHY NORMAN

1932
Gelatin silver print
11.3 x 9.2 cm.
GEH NEG: 5503
74:0052:0001
INSCRIPTION(S):
Verso–[in pencil] "249D"
NOTES:
Variant of image published in *Beyond a Portrait: Photographs, Dorothy Norman and Alfred Stieglitz.*

179. PORTRAIT OF DOROTHY NORMAN

1932
Gelatin silver print
9.5 x 7.2 cm.
Gift of Dorothy Norman
68:0027:0001
INSCRIPTION(S):
Verso–[in ink on label] "E2. Portrait of Dorothy Norman—Original by Alfred Stieglitz 1932"
[in pencil] "Eastman House"
NOTES:
In a letter accompanying the donation of this work to the Eastman House, Dorothy Norman stated that she was "making this gift... to honor the extraordinarily fine work that Mr. Newhall continues to do. I want you to know how much I admire his scholarship as well as all of his other fine qualities." [Dorothy Norman to Dr. Cyril Stoud, March 4, 1968]

180. HANDS— DOROTHY NORMAN

1932/printed 1947 by Lakeside Press, Chicago; Published by Twice a Year Press, New York
From: *Stieglitz Memorial Portfolio*, 1947
Photomechanical (halftone) reproduction
11.2 x 9.3 cm.
Museum purchase
GEH NEG: 48936
67:0120:0015
INSCRIPTION(S):
Recto–[printed lower right] "15"

181. POPLARS, LAKE GEORGE

[Published title: POPLAR TREES, LAKE GEORGE]
1932
Gelatin silver print
24.4 x 19.2 cm.
GEH NEG: 5521
74:0052:0059
INSCRIPTION(S):
Verso–[in pencil] "23E" "x [circled]"
NOTES:
Published title from *Alfred Stieglitz: Photographer.*

182. POPLARS—LAKE GEORGE

1932/printed 1947 by Lakeside Press, Chicago
Published by Twice a Year Press, New York
From: *Stieglitz Memorial Portfolio*, 1947
Photomechanical (halftone) reproduction
21.1 x 16.5 cm.
Museum purchase
GEH NEG: 48938
67:0120:0017
INSCRIPTION(S):
Recto–[printed lower right] "17"

183. [Margaret Prosser's clasped hands in lap]
1933
Gelatin silver print
9.2 x 11.7 cm.
GEH NEG: 10205
74:0052:0037
INSCRIPTION(S):
Verso–[in pencil] "OK 515B"

184. GEORGIA O'KEEFFE
1933
Gelatin silver print
24.1 x 19.4 cm.
GEH NEGS: 27791, 10208, 1532
74:0052:0065
NOTES:
Variant published on page 106 of John Szarkowski's *Alfred Stieglitz at Lake George*.

185. HEDGE AND GRASSES, LAKE GEORGE
[Published title: LILAC BUSHES WITH GRASS, LAKE GEORGE]
1933
Gelatin silver print
19.0 x 23.9 cm.
GEH NEG: 37387
74:0052:0095
INSCRIPTION(S):
Verso–[in pencil] "44E"
NOTES:
Published title from *Alfred Stieglitz: Photographer*.

186. LAKE GEORGE
1934
Gelatin silver print
23.8 x 18.5 cm.
GEH NEG: 37378
74:0052:0066
INSCRIPTION(S):
Verso–[in pencil] "25B"

187. GRAPE LEAVES AND HOUSE, LAKE GEORGE
[Published title: PORCH WITH GRAPE VINE, LAKE GEORGE]
[Published title: GRAPE LEAVES AND PORCH, LAKE GEORGE]
1934
Gelatin silver print
23.9 x 19.1 cm.
GEH NEG: 5520
74:0052:0097
NOTES:
Published titles from *Alfred Stieglitz: Photographer* and *Alfred Stieglitz: An American Seer*.

188. [Ford V-8]
1935
Gelatin silver print
19.5 x 24.3 cm.
GEH NEG: 20984
74:0052:0093
INSCRIPTION(S):
Verso–[in pencil] "15B" "A–1Z"

189. NEW YORK SERIES—SPRING
1935/printed 1947 by Lakeside Press, Chicago
Published by Twice a Year Press, New York
From: *Stieglitz Memorial Portfolio*, 1947
Photomechanical (halftone) reproduction
21.0 x 16.5 cm.
Museum purchase
GEH NEG: 48934
67:0120:0013
INSCRIPTION(S):
Recto–[printed lower right] "13"

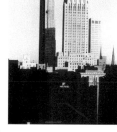

190. NEW YORK SERIES, SPRING
1935
Gelatin silver print
24.2 x 19.2 cm.
Museum purchase, ex-collection Georgia O'Keeffe
GEH NEG: 29049
81:2162:0001
INSCRIPTION(S):
Verso–[in pencil] "A1 2" "4D" "Stieglitz"
NOTES:
Variant images titled "From the Shelton."

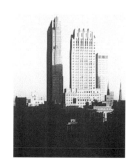

191. NEW YORK SERIES. 1935

[Published title: FROM THE SHELTON, LOOKING WEST, 1933?]
1935
Gelatin silver print
24.2 x 19.1 cm.
GEH NEGS: 16834, 3063
74:0052:0074
NOTES:
Published title and date from *Alfred Stieglitz: Photographer*.

192. LAKE GEORGE

1936
Gelatin silver print
11.8 x 9.3 cm.
GEH NEG: 10202
74:0052:0036
INSCRIPTION(S):
Verso–[in pencil] "241C"

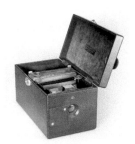

Stieglitz's Cameras

193. TISDELL & WHITTLESEY DETECTIVE CAMERA

Tisdell & Whittlesey, New York, N.Y.
ca. 1888
74:0037:1972

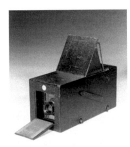

194. REFLEX HAND CAMERA (4- x 5-INCH)

Reflex Camera Company, Yonkers, N.Y.
ca. 1900
74:0037:2325

194a. 10 3/4-INCH GOERZ DOUBLE ANASTIGMAT SERIES III LENS

[shown on camera]
C. P. Goerz, Berlin, Germany
ca. 1910
77:0127:021

195. RB AUTO GRAFLEX CAMERA (4- x 5-INCH)

Folmer & Schwing Division of Eastman Kodak Company, Rochester, N.Y.
ca. 1910
74:0037:0032

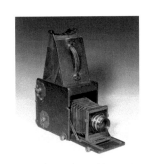

195a. 10 3/4-INCH DOUBLE ANASTIGMAT SERIES III LENS

[shown on camera]
C. P. Goerz, Berlin, Germany
ca. 1910
77:0127:0021

195b. 8 1/4-INCH CELOR SERIES 1B LENS

[not shown]
C. P. Goerz, Berlin, Germany
ca. 1904
74:0037:0032

196. EASTMAN NO. 2-D VIEW CAMERA (8- x 10-INCH)

Eastman Kodak Company, Rochester, N.Y.
ca. 1921
78:1371:0054

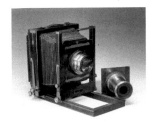

196a. 14-INCH DOUBLE ANASTIGMAT TYPE B SERIES ID LENS

[shown on camera]
C. P. Goerz, Berlin, Germany
ca. 1920
77:0127:0020

196b. 18-INCH COOK ACHROMATIC PORTRAIT LENS

[shown next to camera]
Taylor, Taylor & Hobson, London, England
ca. 1920
77:0127:0002

This publication is the result of the dedication of museum staff, professional colleagues, and friends, who gave generously of their time and talents. I wish to express my appreciation to staff members for their invaluable support and assistance in realizing this project: Anthony Bannon, director; Todd Gustavson, curator of technology; Sean Corcoran, curatorial assistant; Del Zogg, senior cataloguer; David Wooters, archivist; Joe Struble, assistant archivist; Janice Madhu, assistant archivist and manager of rights and reproduction; Becky Simmons, assistant librarian; Jim Conlin, registrar; Stacey VanDenburgh, assistant registrar; and Grant Romer, director of the Museum's conservation department. I owe a great debt of gratitude to Jeanne Verhulst, associate curator of exhibitions, for advice that more than once kept me pointed in the right direction.

With tolerance and expertise in the face of maddening deadlines, the Museum's publications staff supervised the organization and production of this catalogue. I am grateful to Robyn Rime, publications manager; Teri Allbright, copyeditor and proofreader; Barbara Puorro Galasso, head of photographic services, for her constant dedication to producing the highest caliber photographic reproductions; and especially Amy E. Van Dussen, art director, who not only designed this book and coordinated its print production, ensuring its quality, but was also a generous collaborator. I also wish to thank the publication's editor, Ann Stevens of East River Editorial, who lent her finely honed skills and good humor to the successful realization of this publication.

My deepest appreciation goes to Eugenia Parry and Laura Downey, who authored the essays for this publication. Their consummate understanding of their subjects offered fresh insights and unveiled valuable information. It is our hope that their work will inspire new perspectives for future inquiry about the legacies of both Alfred Stieglitz and Georgia O'Keeffe. I cannot thank them enough for their refreshing contributions to our understanding of the Museum's Stieglitz collection.

For providing much needed research and assistance with regards to the Stieglitz holdings at other institutions, I wish to thank Katherine Ware, curator of photographs, Philadelphia Museum of Art; Anne Havinga, assistant curator of photographs, Museum of Fine Arts, Boston; Mary Daniel Hobson, research assistant, San Francisco Museum of Modern Art; Laura Muir, research associate, The Metropolitan Museum of Art, New York; Kristin Nagel Merrill, collection manager, photography collection, The Art Institute of Chicago; and, in particular, Sarah Greenough, curator of photographs, and Janet Blyberg, assistant to the Alfred Stieglitz project, National Gallery of Art, Washington, D.C.

I would like to extend my deepest appreciation to those organizations and individuals who helped make this publication possible through their generous support and enduring commitment to photography: The Publishing Trust of George Eastman House; and The Georgia O'Keeffe Foundation, its former president, Elizabeth Glassman, and current director, Agapita Judy Lopez.

Finally, I wish to thank my family, in particular Jack, Margaret, and Kevin Mulligan, for their always wise counsel and sustaining enthusiasm.

Therese Mulligan

Published by The Publishing Trust of George Eastman House.

Editor
Therese Mulligan

Essays
Eugenia Parry, Laura Downey, and Therese Mulligan

Editorial Coordination
Robyn A. Rime

Copyediting
Ann H. Stevens, East River Editorial

Proofreading
Teri Allbright

Design and Production
Amy E. Van Dussen

Photographic Services
Barbara Puorro Galasso

Coordination of the accompanying traveling exhibition
Jeanne Verhulst

Sponsorship of the accompanying traveling exhibition
Eastman Kodak Company

Distribution
University of New Mexico Press, Albuquerque, New Mexico

Printing Information
Scanning, color separation, printing, and binding by
Upstate Litho Inc., Rochester, New York.

Printed on Vintage Velvet Cream.

Set in Fruitger Light with display in Bauer Bodoni.

Duotone and four-color reproductions were scanned from first-generation positives
taken from the original photographs and printed using stochastic imaging.
Stochastic imaging replaces the halftone screens used in conventional offset lithographic
printing with a random dot pattern, creating the appearance of a continuous tone image.